CORPORAL POLITICS

LOUISE BOURGEOIS

ROBERT GOBER

LILLA LoCURTO and WILLIAM OUTCAULT

ANNETTE MESSAGER

RONA PONDICK

KIKI SMITH

DAVID WOJNAROWICZ

Essays by Donald Hall, Thomas Laqueur, and Helaine Posner

MIT LIST VISUAL ARTS CENTER CAMBRIDGE

BEACON PRESS BOSTON

Published in conjunction with the exhibition
CORPORAL POLITICS
MIT List Visual Arts Center
December 12, 1992 – February 14, 1993

Library of Congress Cataloging-in-Publication Data

Hall, Donald, 1928–
Corporal politics : [artists] Louise Bourgeois … [et al.] / essays by Donald Hall. Thomas Laqueur, and Helaine Posner.
p. cm.
Exhibition catalog.
ISBN 0–8070–6601–X
1. Body art—Exhibitions. 2. Body, Human, in art—Exhibitions. 3. Art, Modern—20th century—Exhibitions.
I. Laqueur, Thomas Walter. II. Posner, Helaine. III. MIT List Visual Arts Center. IV. Title.
N6494.B63H36 1993
704.9'42'090480747444—dc20
92–34401
CIP

Typeset in Caslon
Printed on Warren Lustro Dull by The Elm Tree Press
Designed by Glenn Suokko

© 1992 MIT List Visual Arts Center
Wiesner Building, 20 Ames Street
Cambridge, Massachusetts 02139

Copublished by
Beacon Press
25 Beacon Street
Boston, Massachusetts 02108

CORPORAL POLITICS

Lenders to the Exhibition

Asher-Faure Gallery, Los Angeles
Galérie René Blouin, Montreal
Eileen and Michael Cohen
Paula Cooper Gallery, New York
Galérie Crousel-Robelin BAMA, Paris
Fawbush Gallery, New York
fiction/non-fiction, New York
The Arthur and Carol Goldberg Collection
Hirshhorn Museum and Sculpture Garden,
Smithsonian Institution, Washington, D.C.
Michael and Susan Hort
Lannan Foundation, Los Angeles
Lilla LoCurto and William Outcault
Penny and David McCall
Robert Miller Gallery, New York
The Morton G. Neumann Family Collection
Rona Pondick
P.P.O.W., New York
Private Collection
Tom Rauffenbart
Gary Rubinstein
Kiki Smith
Lise Spiegel Wilks
Susan and Peter Straub
Marc and Livia Straus
Coleccion Tubacex, Spain

Table of Contents

Acknowledgments

Support for this project has *not* been provided by the National Endowment for the Arts, a federal agency. And therein lies a tale.

When our application to the NEA Museum Program for partial support of this project passed the two review stages only to be derailed without explanation at the level of the acting chair, it became clear that *Corporal Politics* had been pressed into the service of Electoral Politics. Our original curatorial intent was simply to bring together works by several of the most serious artists practicing today who share a conviction that the fragmented human body is an appropriate vehicle to convey the feel and focus of the moment.

Whether it was the medium (the body) or the message (its disintegration) that triggered the rejection and ensuing controversy will long be debated. What cannot be denied is that the entire project became co-opted by many with agendas far removed from the exhibition's original purpose. We intended neither to taunt the right nor flaunt the Constitution. The MIT List Visual Arts Center has a long tradition of exhibiting works that take on testy topics. Contemporary art is a barometer of the spiritual climate, and responsibility for uncomfortable weather cannot be laid at the feet of the forecaster. It is our urgent hope that the works brought together here will be allowed to stand on their own, and will be acknowledged as unflinching, often wrenching, occasionally humorous, but always honest responses to a raw moment in social history.

The NEA notwithstanding, support for this project *has* been forthcoming from many quarters and it is as much a pleasure as a responsibility to acknowledge them here. Aerosmith, a band with a conscience, contributed very generously on behalf of art without interference. Jon Robin Baitz, a noted young playwright, also made an important donation, the symbolic equivalent of his recent NEA fellowship, to our project as well as to the Anderson Gallery at Virginia Commonwealth University, our partner in NEA rejection. A number of other individuals, some known to us, others new friends, made contributions. Thank you Henry Deeks, Simson Garfinkel, Judith Goldman, John Kunstadter, Jo Ann Rothschild, Fine Lines Precision Vinyl Graphics, and PCW Communications for this moral and financial support. Many individuals were moved to write on our behalf to the NEA to express support for its founding principles and to protest their recent politicization. Though these advocates are too numerous to list, their generous and vocal involvement was extremely heartening.

Colleagues at MIT took vigorous stands on behalf of merit and peer review as well as freedom of inquiry. President Charles Vest and Associate Provost for the Arts Ellen Harris in particular spoke out unhesitatingly and sustained our spirits. Mary Haller and the Office of the Arts helped immeasurably in our fiery baptism in dealing with unprecedented numbers and varieties of press demands and inquiries.

Our collaboration with Beacon Press on this book has been an unalloyed pleasure. These principled publishers, under the direction of Wendy Strothman, provided a rare model of courage, integrity, and good humor. Donald Hall's straight-speaking, both in Washington and in these pages, reminds us in the most convincing way of the power of art. His uncompromising standards and energy will continue to be an inspiration. Thomas Laqueur, the authority on the construction of the modern body, cheerfully agreed to offer observations on its destruction. Glenn Suokko's elegant catalog design constructs a coherent body from many fragments, the premise of the exhibition notwithstanding.

The Arts Action Coalition in New York and the People for the American Way in Washington also provided support and guidance in informing and shaping our response to the challenge of this unprecedented public rejection.

The principal players, of course, are first the artists, whose consistent support and cooperation has only underscored our original commitment. And finally, the List Visual Arts Center team. Never have I known such a solid body of professionals and friends.

Katy Kline
Director
MIT List Visual Arts Center

Art and Its Enemies

DONALD HALL

In 1990 fundamentalist preachers (aka fundraisers) joined with bigoted politicians and columnists to attack the National Endowment for the Arts. It had been noted that the collapse of the Communist empire left the right-wing heartsick for villains. Sex is the new villain, and its henchman is art. A conspiracy of intellectual capons—joining together Jesse Helms, George Will, Donald Wildmon, Patrick Buchanan, and Jerry Falwell—pretends to outrage over NEA-funded art, largely on the grounds of "obscenity" or "pornography." This is disingenuous nonsense. Nothing the NEA has sponsored would sell for a nickel on the remainder table of your neighborhood pornshop, and the NEA remains the most benevolent of organizations. It supports quilt-making in Appalachia and ballet in Oklahoma; it reaches out to inner cities on the one hand and brings art to the outlands on the other. In its quarter century, the NEA has extended and multiplied the occasions of American art—both geographically and socially.

NEA attackers understand and loathe the organization's deliberate virtue. They realize that anyone who funds work not yet assembled—be it an exhibition or a magazine—funds the incompletely known: consequently, something will inevitably offend somebody. If we wish to prevent all possible offense, our only recourse will abolish all funding. And abolition of support for the arts is the capons' true agenda. Art is a comfortable target, for art commands no power source to hire lobbyists or contribute funds to politicians. Who supports the arts? Not very many people, not very much. Even liberal commentators—Sam Donaldson and Cokie Roberts on a celebrated occasion, for instance—collapse under the assault of the art-bashers, falling back and conceding that the federal government should withdraw its support for the arts. These are political not artistic people; they avoid the tedium of a struggle, and for them art is expendable, something to throw to the conservative wolves.

For others, art lives at the center of the examined life; the poet and obstetrician Williams Carlos Williams claimed for poetry that people die daily for the want of it. If in recorded history, all governments had refused funding to the arts, we would lack the art of Greece that Pericles funded; we would lack Renaissance painting and sculpture sponsored by the wealth of princes both secular and religious; we would lack music created for the supported orchestras and opera companies of Europe in the eighteenth and nineteenth centuries. In human history, there is little art without prior support, because great art has seldom sold like bread or broomsticks. People who call for art to support itself in the marketplace call for the diminishment of art.

Art extends human consciousness, touching upon or exploring difficult feelings, making public our grief and our fear, our insecurity and our pride, our sexuality and our fear of death. This painful making public benefits our health. The forces of repression, however, dread and fear it because they must deny extreme emotion as well as diversity of experience. Art upsets us *in the cause of* expanding

and extending human consciousness, revealing the emptiness of conventions by looking under the surface. Often it is dark under the surface, and unpleasant—but art exposes reality with its conscious light. Therefore, art becomes an enemy for any group that wishes to deny its own desires or to hold itself down; art embodies the nervous reactionary's alienated characteristics. When an artist provokingly titles a photograph *Piss Christ*, the title becomes a fundraising event and a weapon for art-bashing.

It is language, seldom an image, that offends—even in the visual arts. *Pineapple Juice Christ* would have captured no five dollar checks from the outback. It is not the art itself that provokes outrage—the pigment, the words of a poem, the performer on the stage—but repeated (often inaccurate) anecdotes of performance or poem or picture. The capons who endlessly tell these stories—how many times have we heard of a body smeared with chocolate?—never experience the work of art itself. But a work of art is only itself; it is not a story about itself.

Because the art-bashers bash, should the artist cower and self-censor? When INDIGNATION in capital letters leaps from the office machinery of fundamentalist fundraisers, should administrators of the arts prostrate themselves? Dangerous titles are potent but so are bigotries. When Patrick Buchanan runs against George Bush, he scores three hits in one at-bat by advertising excerpts from a film (art, score one) about black homosexuals (score two, score three) funded in a small way by the NEA. Hatred and fear of sexuality contrive and conspire with fear of ethnic minorities; a third and less noticed fear is that of art, most especially of living artists. These three companions wear the same face, since all symbolize or embody the unleashing of human feeling and therefore the expansion of consciousness.

When Calvin Thomas runs out of topics for columns, art-bashing fills up the blank space. James J. Kilpatrick rolls on his back in stereotypes of "poets in their garrets." Art makes bullies nervous, so art is something to gang up on. From the rise of modernism late in the nineteenth century, idiots and columnists have hated all new art. It's axiomatic: After one's senior year in college, nothing new is any good. I can imagine two good reasons for this continuing commonplace: First, it excuses laziness (never underestimate laziness as a source of human behavior) because if it's no good you don't have to read it, see it, hear it, or listen to it; second, art often uses as its material the concerns of our own time, forcing us to acknowledge a difficulty or an injustice about which we might (if persuaded) need to change our minds or our behavior. The art of earlier times, deriving partly from obsolete social or psychological concerns, fails to charge us with responsibility.

Current leadership at the NEA has worked to disconnect the Endowment from anything that might upset anybody. (I speak of leadership only, for I believe that the rank and file of the NEA—and even the National Council—remains largely committed to promoting art and excellence.) When President Bush fired John

Frohnmayer in 1992 in response to Patrick Buchanan's bigotry, Frohnmayer's assistant, Anne-Imelda Radice, who had been planted at the NEA by White House neoconservatives—became acting chair, in which capacity she served her sponsors.

On May 5, 1992, testifying before Congress, the acting chair vowed to deny funds for art that was "sexually explicit," or otherwise incorporated "difficult subject matter." In effect, Radice promised to overturn Congress's original insistence, written into the law that founded the NEA, that decisions be aesthetic and not based on subject matter. She went on, "If we find a proposal that does not have the widest audience . . . we just can't afford to fund that." If this statement were taken literally, 98 percent of the NEA's proposed grants would go unfunded. As little as one half of one percent of NEA grants feature sexual explicitness; but certainly a good half of them are "difficult"—and most of them do "not have the widest audience." Heavens to Betsy, neither Rembrandt nor Beethoven nor Shakespeare nor Puccini—not even the *Nutcracker*—has the audience of *Cats*, "Studs," the dog track, or Leroy Neiman. As soon as we suggest that some things are better than other things, we become elitist. Fair enough. Should we propose a National Endowment for Kitsch?

One week after her congressional testimony, the acting chair overturned a grant to the MIT List Visual Arts Center for *Corporal Politics*. At the same time, she denied a grant to the Anderson Gallery at Virginia Commonwealth University for a show that also included images of sexual organs. The proposal for *Corporal Politics* featured four eminent contemporary artists and was recommended on aesthetic grounds by an NEA panel—composed of people knowledgeable in contemporary art. When Radice overturned the panel's recommendation, she claimed that she acted for aesthetic reasons, but the art world understood that she was fulfilling her congressional pledge to deny funds for anything "sexually explicit." The exhibition contains—among other bodily images such as hands and feet—representations of mammary glands, testes, and phalluses—organs never before seen in works of art, except, of course, in fifth-century Greece, the Renaissance, and nineteenth-century France.

The acting chair defended her actions by citing the lack of "artistic excellence and artistic merit," as well as "long-term artistic significance . . ." Repeatedly asked to elaborate, she refused. Poverty of language indicates ethical poverty; the refusal to argue proclaims disingenuousness. Predictably, the neoconservative *Washington Times* ran several stories praising these tough-minded aesthetic decisions, and a small men's chorus of art-bashing right-wing columnists praised the acting chair for withholding funds from two art exhibitions they had never seen. When a New York playwright donated his NEA money to MIT, his reward was columnar petulance from George Will. In the resulting chaos, the NEA lost staffers of unusual ability, two artists refused to accept gold medals for the

arts, and two panels—convened to recommend future grants—refused to finish their work: Why struggle, when disinterested aesthetic judgment may be over-turned by hypocrisy attempting to appease art's enemies?

Some results of this brouhaha are happy, and the artists of *Corporal Politics* may profit from official shabbiness. More people will attend the exhibition, more people will read this catalog. The artistic excellence of *Corporal Politics* will be-come obvious when viewers see actual art instead of reading stories about it. They will find this exhibition both new and traditional. Artistic separation of body parts is not new. Even the classic bust is an abstraction, and sketches or cartoons of body parts have appeared in all ages. Both praying hands and analytic cubism dissected the body. In the fragmentation of *Corporal Politics*, we find elements of iconoclasm, as if noses and genitalia removed from old sculptures—by zealots and target-practicing soldiers—have migrated to the List Visual Arts Center in Cam-bridge. Little of the exhibit is genitalia. It is probable that the title of one work—Robert Gober's *Genital Wallpaper*—provided, frivolously enough, the source of official stricture. *Genital Wallpaper*, like its title, is witty: Lavatory graffiti, ironi-cally domesticated as wallpaper, makes an art that is serious, funny, and disturb-ing. If fundable art must not disturb us, the best art will go unfunded.

If Gober's work is witty, so is Rona Pondick's, who makes fearsome doll-like fragments embedded like certain tumors with human teeth, or multiplies bottle-breasts in an assemblage dark and comic together. Kiki Smith, however, is a cool and classic maker, and the provenance of her art includes surgery and the microscope. The French collagist Annette Messager is fourth of the original art-ists whose work, it was deemed, lacked "artistic merit" and "artistic excellence." The List Center has since this judgment added two sculptures by Louise Bourgeois (who will represent the United States at the 1993 Venice Biennale), work by the late David Wojnarowicz, and a video-installation by Lilla LoCurto and William Outcault.

We can learn much from the wide sources and resources brought to the walls of the List galleries in this exhibition, from graffiti to the scientist's laboratory to the workshop of the mad dollmaker. Our American arts thrive—and public policy toward the arts needs overhauling, if merely by the moderate courage it takes to deny the deniers, the cabal of art-bashers among politicians, columnists, and ap-pointed officials.

Donald Hall is a poet
and member of the National
Council on the Arts.

13

Clio Looks at Corporal Politics

THOMAS LAQUEUR

The history of Western civilization has both hidden the body from view and explored it obsessively. On the one hand, there is a strong historical bias against the very premise of this exhibition, against the notion that there is, or at least that there ought now to be, a public, contentious discourse of the flesh. On the other hand, the body is one of the great political arenas of our times.

Corporal politics—making manifest the body in all its vulnerable, disarticulated, morbid aspects, in its apertures, curves, protuberances where the boundaries between self and world are porous—is somehow indecent. "It is in keeping as far as possible out of sight, not only actual pain, but all that can be offensive or disagreeable to the most sensitive person, that refinement exists," writes the great liberal philosopher John Stuart Mill. In fact, it is a sign of the "high state of civilization," of the "perfection of mechanical arrangements," that so much can be kept hidden.

The infliction of pain, as Mill points out, is delegated "to the judge, the soldier, the surgeon, the butcher, the executioner." Hangings or beheadings are held behind prison walls and not before a raucous carnival crowd; people suffer and die in hospitals and not on the streets; animals are killed and processed God knows where but they certainly do not bleat and bleed in public courtyards. In most of the countries of northern Europe, beginning in the middle of the nineteenth century, it was forbidden to beat dogs, horses, or other animals in public. Clothes and carpets appear in our shops with not the slightest sign of who made them and under what circumstances; were they sewn by displaced and vastly underpaid fishermen's wives in the Dominican Republic or knotted by ten-year-old boys and girls in Rajestan?

More generally, the processes of civilization in the past four hundred years have served to secure the body's boundaries. Medicine has exposed the distinct paths of its fluids and allocated their study to various specialists: hematologists get blood except the menstrual sort which is allocated to gynecologists; nephrologists and urologists get urine; opthamologists get tears and tear ducts. From antiquity to the eighteenth century, for patients and doctors alike, mucus, feces, urine, pus, blood, menstrual blood, milk, semen, tears were all understood as fungible versions of one another that oozed or flowed from ill-guarded openings and orifices. Today they are closely guarded, clearly distinguished, and somewhat embarrassing superfluidities that one gets rid of discreetly or "produces" in the rest room for diagnostic purposes. In the old days the body constituted a sphere of remarkable changeability: milk could move about and be extruded from various orifices; matter, almost like a Hindu deity, could appear in a variety of avatars—freckles might vanish only to show up again as bad breath; wind in the womb might be relieved though the ears. In other words, a complicated interpretative process in which nothing was taken as pure fact determined the meanings of a body that was open to the cosmos.

As for daily life, the admonitions of sixteenth- and seventeenth-century courtesy books—do not spit in the common serving dish, do not wipe your nose on your sleeve, do not fart loudly at the table, do not relieve yourself in public—would seem superfluous today. To be civilized is precisely not to do these sorts of things; Emily Post is about fine tuning. Henry VIII's Groom of the Stool—the title was changed to the more decorous Groom of the Stole under Elizabeth I—gained considerable cachet from his intimacy with the king's body, specifically with his shit. Contrast this with the outcry that ensued when President Johnson held court in the john. (The role that the bodies of our leaders play in modern politics is deeply ambiguous. On the one hand, they are irrelevant—how could it be otherwise in the age of bureaucratic rationality. On the other, they are riveting—never has the demos known so much about the insides of a public figure as we learned about the large intestine of President Reagan.)

In a sense *Corporal Politics* demands the return to public discourse of pain, sickness, fluids, and the meaning of artifacts. Bodies and things do not speak for themselves in some magical, unmediated fashion, but their manifest presence in the art displayed here—their decontextualization—powerfully makes the claim that there is something to be said. Whatever else Annette Messager's *"Story of Dresses"* or *"Histoire des Robes"* (p. 44) might mean, these constructions demand that we recognize artifacts of cloth as entailing an artificer. They are not overtly political as are the narrative pictures (Figs. 1–2): the women who luxuriate in their rich dresses stand in stark contrast to the poverty-stricken seamstress whose body is wasted into the cloth and thread that dresses her betters so opulently. One body is sacrificed for the display of another. Scores of pictures and cartoons like these—starving tailors in bell jars juxtaposed with wonderful clothes at the Great Exhibition of 1851 is another famous example—make a mockery of Mill's ironic claim. Pain is hidden only from those who refuse to see. Messager, simply by making art of women's work, focuses the viewer's attention on the making itself and on the bodies which engage in it.

David Wojnarowicz's *Untitled (for Peter Hujar)* (p. 52) is at its most elemental a deathbed painting—the genre, now almost defunct, whose great exemplars are the paintings of the death of Christ, transformed in thousands of pictures into secular *memento mori*. Although these paintings assimilate death into culture—that is the point after all—the fact of death, its "disagreeableness" to the "sensitive person," is never entirely lost. That, too, is the point in even the most cultivated Victorian scenes and Wojnarowicz's collage is far from these: more vivid, more horrifying, devoid of the sentimentality that would soften death. The text he imposes on the images flies in the face of the whole process of civilization that wants, when convenient, for the body to disappear, to stay decorously closed: "I'm carrying this rage like a blood filled egg and there's a thin line between the inside and the outside...and that line is simply made up of blood and muscle and bone."

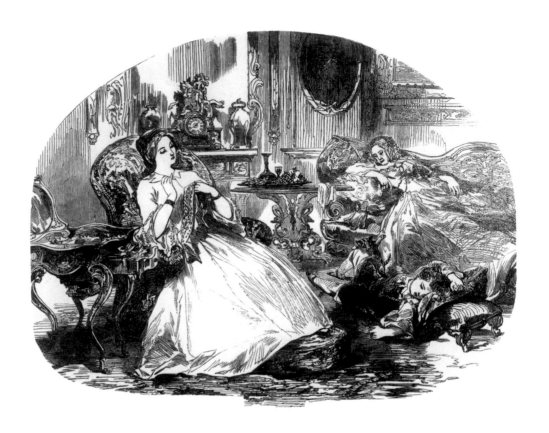

Rage is the body exploded across its bounds, the "inside beginning to erode," "the egg is about to crack." "In your face," as a political gesture, means literally "no longer contained in my body," no longer hidden from view but violently thrust outward.

There is an odd way in which several of these pictures discomfort by making strange again a body that had been rendered tame to earlier generations. In some cases the echoes of the past are elusive though present. Rendering tissues in glass as in Kiki Smith's glass sperm (p. 47) is not new. (I think of the eighteenth-century architect Pierre Giraud's scheme for melting down bodies, vitrifying them, and producing medallions of the deceased with the glass made from their flesh and bones.) But I am not sure why glass, an unlikely medium for opaque bodies and body parts, has the effect it does. Hair, as in Robert Gober's sculptures, has a fairly well defined historical lineage and is unsettling precisely because its references to the past could once be seen as benign.

Hair replaced the heart as what might be preserved of the dead sometime in the late seventeenth century. It became the corporeal auto-icon par excellence, the favored synecdoche—the real standing for the symbolic—perhaps not eternally incorruptible but long lasting enough, a bit of a person that lives eerily on as a souvenir. Hair was intimate and yet easily detached; it was far more democratically available than embalmed hearts had been. Cameo portraits were set on backgrounds of the departed's hair; gold-framed windows in brooches contained bits

Figs. 1–2.
The contrast between the ample, well-clothed bodies of the rich and the emaciated bodies of the ragged poor who make possible their lives of plenty is a common theme in the Victorian press.

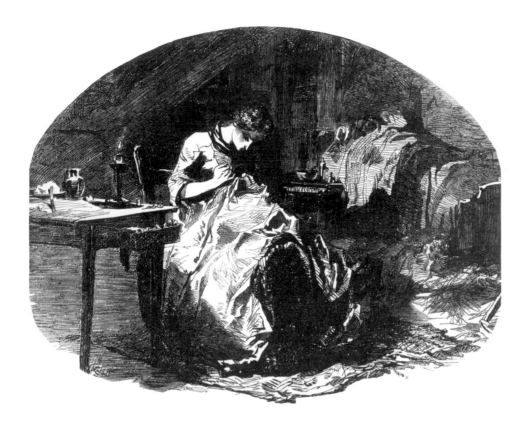

of hair; bracelets were woven of it; it was inset into rings. There is, thus, nothing very new about hair in objects and it might, in fact, conjure up comforting images of a bygone lugubrious sentimentality.

But hair in Gober's work resists this tradition while it makes use of its cultural resonance. In the first place, of course, the objects in which it is embedded are disturbing even without hair. The untitled beeswax torso (p. 40) has the same sort of freakish fascination that drew viewers to pictures of Renaissance monsters, half man and half woman, or to the freak shows of modern circuses. My first impression of *Untitled (Leg)* (p. 39) is in the context of the making of prosthetic limbs after the Great War, when artists were hired as the experts on what legs should really look like. Life, insofar as strapped-on extremities could be incorporated into the body, imitated art, and yet here it is as pure art again. Where exactly does this leg belong, and to whom, and what is it doing—detached—here? The texture of wax also makes it uncomfortably real—no accident that it was the preferred medium for eighteenth-century anatomical figures and for Madame Tussaud— and now, of course, we see art through the lens of museum realism.

But the hair—around the base of *Untitled (Candle)* (p. 41), on the male half of the divided torso, on the leg—shares the nineteenth-century quality of a human auto-icon without its sentimental sweetness. Detached hair can never quite mean the same as it did before the world saw photographs from the concentration camps. It does not, in Gober, remind one of a dead beloved but of an anonymous

someone—whose hair is this anyway?—no private memory but a "disagreeably" public reminder of how easily bodies come apart and lose identity—one of the several jokes in the *Genital Wallpaper* (p. 43) as well. In short, a whole facet of this exhibition flies in the face of what modern civilization has tried to do, to hide the body behind images, language, culture.

But of course corporal politics rages not only in the face of prohibitions against displays of the body but also as a result of them. The body since the eighteenth century has become a site to be explored, opened up, revealing what is hidden below the surface and *therefore* profoundly true. The first stages of this exploration go back to the extravagant public dissections of the Renaissance in which the opened body, as opposed to a venerated text, was proclaimed to be the font of truth. In the early sixteenth century, for the first time ever, anatomy books contained illustrations which were meant to stand for the thing itself, as near as possible to what was really there. In fact, dead bodies spoke, as if alive, inviting viewers to explore beneath the skin, beneath even the muscle, to the very depths of being.

But still the sixteenth-century body did not stand alone. It was understood by the founders of anatomy to be redolent with the cosmos, to speak of truths that existed beyond their bounds: truths of the stars, of metaphysical reality, of divine origin. Man was understood to be the measure of all things not because *his* body was foundational but because it stood poised strategically between heaven and earth, between God and the angels above and lesser creation below.

By the late seventeenth century, however, the body ceased to be understood as a microcosmic representation of the cosmos and was seen instead as a part of nature which could and should speak for itself against priestcraft and obscurantism. The cultural imperative to see, to reveal, to dissect, and to represent all of this visually produced an unprecedented explosion of images of what lay beneath the surface, which in turn lent weight to the idea that the specificities of the flesh were what ultimately mattered. The body came to be seen as the foundation for two biologically opposite sexes which in turn determined gender roles. (Before that, the dominant paradigm imagined there to be but one sex, male, of which the female was a lesser version; a metaphysics of gender was but imperfectly represented in, not founded on, anatomy and physiology.) Theories of physical race came to define differences between people; criminality could be traced to the brain not the soul; virtue would arise from healthy bodies in a healthy environment, not from the tending of souls.

And in another register, disease increasingly came to be understood not as a general disordering of the body—a "dis-ease" with powerful subjective and individualistic qualities so that only you could have precisely your illness—but as something very specifically wrong with some particular part. To be sick meant to have a particular, objectively defined, lesion. Thus AIDS *is* an impairment of the

immune system manifested in T cell count. Wojnarowicz can point to microscopically small corpuscles floating down an artery as the absolutely central image of his allegory of AIDS (p. 53); the images of esoteric hematology and immunology are sufficiently intelligible, not just as blood cells but as the essence of disease, to be accessible to nonmedical museum-goers. Surrounding this strong diagonal river of blood are various more socially oriented representations of disease, but pride of place belongs to clinical pathology.

Truth in the body is what Kiki Smith's work is all about. But it is a contentious, fragile, and ultimately elusive truth. When Anton van Leuvenhoek and Hartsoeker during the 1670s first saw little animalcules swimming in semen and de Graef proclaimed the ovarian follicle to be the egg, it seemed as if the sources of life finally could have material correlatives. Semen in the Western tradition may have been called seed, but it had certainly not been imagined as one would sunflower or poppy seeds. In fact, it was not visualized at all. It was the spark of life, the generating force, the efficient cause, the corporeal analogue of the cosmic demiurge, but it was not a thing. Even the female contribution to generation, although understood as material, was never very clearly identified or represented. No one ever sketched or wrote about how it might look; if it was menstruation, it was certainly not what was actually seen as menstrual fluid.

Finally seeing sperm and what were presumed to be eggs did not, however, reveal the secrets of generation, on the level either of reproductive biology or whatever culturally comprehensible event connected children to parents. In part this is because no one could articulate a coherent theory of what sperm and egg actually did. Were humans pre-formed in the egg as the ovists held, or in the animalcules as professed by the spermaticists? In either case fertilization was simply the unlocking of growth rather like Alice swallowing the medicine that made her larger. Were the little swimming creatures in semen parasites that merely stirred the egg into action, in the way that a glass rod could induce frog eggs to be fertile? (This was the view of the great Italian biologist Spallanzani who discovered that the vapor of frog semen—collected from little taffeta trousers in which the amphibians were dressed—could not alone fertilize eggs and who coined the name for the microscopic parasites: spermatozoa.) Only in 1876, and only after people began thinking of the body as composed of cells, were egg and sperm seen to unite, and only in the early twentieth century was it discovered that chromosomes, the parts of the nucleus that took stain, carried genetic material. After the DNA revolution one might imagine the story to be over. DNA is the fingerprint on each sperm; police speak of "genetic fingerprinting." And so Smith's handmade glass sperm with the whorls and loops molded in might be regarded as an end of this happy story.

But sperm are not transparent; neither the body nor its representations speak for themselves. When those who are so passionately for open adoption or against

the anonymous donation of sperm say that not to know the origin of sperm is to lose half of one's heritage, to lose a social and emotional history, to be a victim of "a transfer of ownership of human beings [that] did not end when slavery was outlawed," they are not making a demand for knowing the genome (*Coming Up!* October 1987, p. 11). When Jewish women ask for Jewish sperm—they apparently constitute the only religious community to be concerned with the faith of the sperm—or want to know about the hobbies and interests of donors, they are not asking for fingerprints or codes but for a history of connections which they imagine to be somehow born in semen. Connectedness does not spring miraculously from knowledge of one's biological heritage; biology needs to be translated back into blood, family, flesh of my flesh, heritage. That is, biology has been re-imagined as culture and yet, in a world in which the naturalness of social arrangements and kinship are under such powerful assault, fingerprints in sperm, tiny bits of DNA, carry enormous cultural freight. Kinship somehow has also to seem physically grounded. (I hasten to add that this is not an argument about biology versus culture. Not even James Watson, discoverer of the double helix, would argue that one's Italian heritage or Jewishness or "a place in each person's mind for the father whose genes are theirs" will be made manifest by the Human Genome Project.)

Smith's two bronze sculptures *Uro-Genital System (male)* and *Uro-Genital System (female)* (p. 50) could only have been made in a world in which genitals matter enormously. Enshrined in bronze are *the* organs of difference: metallic corporal politics. But exactly what are the politics beyond the fact that the artist had the sheer chutzpah (dare one say balls) to use the medium of Cellini, Donatello, or Rodin to make art of what one might expect to find, floating in formaldehyde, on the shelf of a pathology laboratory? It would have been clearer in the Renaissance because viewers would have known what to see.

Bodies take on what to us are strange configurations if we believe, as did doctors and the less learned of the sixteenth century, that men and women differ not because one has a penis and the other a vagina, one menstruates and the other does not, but rather that these organs and functions are but imperfect representations of a metaphysical truth—men are hotter than women, which means not that they are warmer to the touch but that they are "more perfect." The new anatomy of the time and the new naturalistic forms of representation which gave it such cultural power, announced visually what Galen, the great Roman doctor, had proclaimed: women are but men turned outside in. The vagina is but an introverted penis, the uterus an interior scrotum; there are male testicles and female testicles, a thick and hot male semen and a more watery and cool female semen. The last of these propositions is simply not true, but the truth of figures 3, 4, and 5 is not dependent on the facts of anatomy. Fixing up errors would if anything make the isomorphism between male and female more convincing. Penises like vaginas fit quite comfortably onto classical female torsos. Thus, at the core of modern

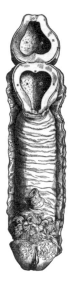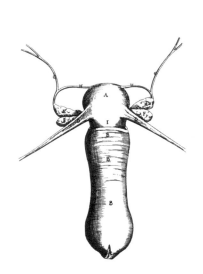

science—in Leonardo and Vesalius—is corporal politics with a vengeance. They make one see the female body as a male body, as a lesser version of the canonical form. The question is not right or wrong anatomy, but this or that vision of a sexual order.

Kiki Smith's bronzes are not of the Renaissance, nor do they seem to announce a modern view of sexual difference. The bladder—an organ with little cultural panache—is the central organ in both. In the female bronze it is suspended from the kidneys and partially covers the uterus; the ovaries are nestled in the broad ligament which takes up much of the surface of the piece. More "uro" than genital here; why no vagina, one wonders, and so much piping instead? The male figure shows the penis hanging not from its root—the crus penis which attaches to the ischial tuberosity is severed here—but from the bladder. No kidneys for the boy but drooping testicles. Male and female are shown as not commensurable, but neither is the point made very clearly that they are incommensurable. Still, I doubt if there has ever been so much loving attention paid to the casting in bronze of any of these organs; indeed, I know of no other bronze broad ligaments or vas deferens. Like Courbet's painting of peasants or stone breakers, Smith's sculptures open new vistas to art.

I am not sure what to make of this. We lack for Smith's bronzes the sort of program Leonardo would have provided. But they do speak, indeed they shout, if not in a language that is instantly intelligible. Prototypically private parts are outed; the borders of the public disturbed. Neither the civilizing process of hiding the body nor the Enlightenment project of having it speak for itself triumphs; and that, in itself, produces a space for corporal politics.

FIG. 3
left: Vagina as penis from Vesalius, *Fabrica.*

FIG. 4
center: The vagina and uterus from Vidus Vidius, *De anatome corporis humani* (1611).

FIG. 5
right: The female torso, in the form of a piece of broken classical art, from which the penis-like vagina in figure 4 was taken, following the artistic and scientific conventions of the time.

Thomas W. Laqueur is Professor of History at the University of California, Berkeley.

21

Separation Anxiety

HELAINE POSNER

The history of Western art has in large part been the history of the representation of the human form. Throughout time, the human figure has been the most valued instrument for exploring and asserting a culture's prevailing worldview. *Corporal Politics* examines a startling phenomenon in late-twentieth-century art, the striking preponderance of the body fragment as a highly charged metaphor for the psychological, social, political, and physical assaults on the individual. The disturbing isolation of body parts and limbs, internal organs, and bodily fluids emphasizes the vulnerability of our bodies and implies physical violence, sexual oppression, and ultimate loss. Artists Louise Bourgeois, Robert Gober, Lilla LoCurto, William Outcault, Annette Messager, Rona Pondick, Kiki Smith, and David Wojnarowicz depict the fragmented form in works that range from the archetypal and universal to the intensely personal and autobiographical.

The dismembered body is the site for the investigation of some of our most urgent contemporary concerns including sexism, sexual identity, reproductive rights, homophobia, social inequity, brutality, disease, and death. Appropriation artist and sloganeer Barbara Kruger warns each of us that "your body is a battleground," while critic Roberta Smith describes the body as a "canvas of conflict." It is difficult, if not impossible, for the individual to maintain a coherent identity and integrated sense of self while under attack. This war on the body and the experience of disconnection it engenders is most often revealed in the work of female and gay male artists. From perspectives outside the white male power structure they are in a painfully privileged position to comment on and critique the politics of division, exclusion, and loss.

The Greek ideal of classical beauty is the tradition on which modern Western art is founded. In the ancient world, the order of nature parallels the order of human reason and man,[1] according to Protagoras, is "the measure of all things." Intellectual and physical perfection are attainable goals and mankind is likened to the gods. The glorification of the human body in the form of the idealized nude male youth or Kouros symbolizes man's elevated status within the cosmos. The practical Romans borrowed Hellenic models and transformed them into monuments to the power, wealth, and administrative prowess of the empire. The strain of realism in Roman portrait statuary emphasizes the position of the rulers as unique individuals of enormous value and authority. In each culture the human body is presented as whole and integral, an image of the perfectibility and power of the individual and the state.

Inspired by the Platonic ideal of beauty, Michelangelo, the archetypal Renaissance thinker, created some of the most enduring and revered works of monumental, heroic sculpture in Western art. In addition to its great physical splendor, Michelangelo's *David* is invested with contained passion, coiled energy, and psychological intensity. During the Renaissance the human figure was regarded as

beautiful not simply because of its natural form but also because of its spiritual significance. The body, biblically inspired and superhuman, was the manifestation of something far greater than its physical form, the character, or the soul. In the late eighteenth and nineteenth centuries, the classical figure served as the embodiment of heroism, civic duty, and revolutionary fervor in the highly dramatic tableaux of the Neoclassical and Romantic painters and sculptors. From David's noble Horatius brothers swearing on their swords to fight to the death for Rome to Delacroix's majestic image of Liberty allegorically leading her people in revolt, the grandeur of the figure was seen as the epitome of such values as courage and patriotism during the formation of modern Europe.

By the late nineteenth and early twentieth centuries major advances in the natural sciences, psychology, sociology, and politics begin radically to reshape the human psyche, and classical and Christian models of the whole, perfect human body start to break apart. Stripped of protective beliefs and traditions, the individual confronts a new and persistent crisis of identity. Mankind's status as the pinnacle of creation is questioned by Darwin's thesis that human beings evolved from lower life forms. The theory of relativity represents the disintegration of any concept of the world as static and predictable, describing a dynamic universe where everything is changing and in process. In this uncertain world, the sound mind is as dislocated as the sound body. The quintessentially human ability to reason and act, which had been extolled from the time of the Greeks to the Enlightenment, is refuted by Freud's psychoanalytical theories revealing man to be basically irrational and subject to the dictates of his subconscious impulses. The Industrial Revolution draws the worker from the farm to the factory so that a formerly integrated agricultural existence is replaced by the alienating, repetitious routine of the assembly line. The once valued individual is absorbed into the anonymity of the crowd. According to Karl Marx, a modern worldview assumes a universe in which "all that is solid melts into air."[2]

The destruction of a centuries-old viewpoint can cause only anxiety. With the approach of the twentieth century, artists could no longer represent reality as a set of fixed ideals; external parameters kept shifting and the artist turned instead to the private world of bodily experience as a creative source. Rodin's magnificent fragmented torsos of the late nineteenth century startled viewers with their lack of historical reference and sensual immediacy. According to the artist, "a well-made torso contains all of life."[3] However true this may be for an artist of Rodin's skill and temperament, the partial figure is also "an attack upon the integrity of our own body image" and appears with greatest frequency during times of stress.[4] The Cubist painters, influenced by Einstein's view of a dynamic physical world, fractured the traditionally unified picture surface. The human figure, presented from multiple viewpoints and various points in time, is transformed into an abstract series of discontinuous planes. The life of the subconscious mind,

1. I have chosen to use patriarchal language in writing about the Western patriarchal tradition and hope the reader will not be offended by this convention.

2. See Marshall Berman, *All That Is Solid Melts into Air: The Experience of Modernity* (New York: Penguin Books, 1988), p. 15.

3. Cladel, *Rodin, l'homme et l'oeuvre*, pp. 97–98, cited in Albert E. Elsen, *The Partial Figure in Modern Sculpture: From Rodin to 1969* (Baltimore: Baltimore Museum of Art, 1969), p. 94.

4. Elsen, *The Partial Figure in Modern Sculpture*, p. 92.

5. Cited in Gardner's *Art through the Ages, 6th ed., vol. II, Renaissance, Modern and Non-European Art* (New York: Harcourt, Brace and Jovanovich, 1975), p. 738.

6. Deborah Wye, *Louise Bourgeois* (New York: Museum of Modern Art, 1982), p. 33. I am grateful to Deborah Wye for her insights into Bourgeois's work.

7. Louise Bourgeois, statement, in Dorothy Seiberling, "The Female View of Erotica," *New York Magazine* (February 11, 1975), p. 56, cited in Wye, *Louise Bourgeois*, p. 27.

as revealed in dreams, fantasies, and private obsessions was the charged subject of the Surrealist painters between the two world wars. In the *Surrealist Manifesto*, André Breton laid out the artist's metaphorical mission "to reestablish man as psychology instead of anatomy," in essence creating a visual counterpart to the psychoanalytic work of Freud.[5] The bizarre and paradoxical juxtapositions of objects and dismembered parts of the anatomy represent a fusion of the artist's internal and external "realities," the familiar, if continually disturbing, experience of dreams and nightmares.

The framented figure proliferates in a multitude of guises throughout the twentieth century. It appears as the master ironist Marcel Duchamp's mechanized bride defiled by her bachelors or as his faceless nude displayed spread-eagle behind the barn door; as the Abstract Expressionist Willem de Kooning's energized, erotic, and mutilated women of the 1950s; or as Jasper Johns's realistic wax body fragments, remote and isolated parts never to be made whole. In contrast to the basically objectified depiction of the fragmented female form by numerous male artists and in keeping with the Surrealists' goal of exploring and expressing the unconscious in art, Louise Bourgeois has created a body of work that is among the most personal, autobiographical, and emotionally rich in contemporary sculpture. She has often used the body part to give physical form to urgent emotions in a remarkable career spanning nearly fifty years. Bourgeois draws directly on her childhood experiences and anxieties to embody such intense feelings as helplessness, fear, and sexual vulnerability, as well as anger, betrayal, and revenge. Incorporating aspects of Cubism, Surrealism, and Abstract Expressionism, the work of Brancusi and Giacometti and developments in Minimalism and Post-Minimalism at various points in time, Bourgeois's art eludes stylistic categorization. In fact, style is not her fundamental concern. Her art is the concrete record of a highly individual and idiosyncratic artist's lifelong attempt to come to terms with the conflict and pain of early experience. Her fearless confrontations with gender, sex, isolation, and death have inspired many younger artists who, like Bourgeois, make art as a personal "strategy for survival."[6]

In many works Bourgeois merges sexual opposites to create new hybrid forms. As she says, "Sometimes I am totally concerned with the female shape—clusters of breasts like clouds—but often I merge the imagery—phallic breasts, male and female, active and passive."[7] At their most primal level, these accumulations of protruding forms, as in *Untitled*, 1990 (p. 32), represent fecundity or the life force—a powerful synthesis between the generative penis and the nurturing breast. Like the artist they are repetitive, obsessive, and express a desire for intimacy countered by feelings of aggression. Bourgeois also explores the tenuous relationship of the individual to the group in the tight clustering of her separate yet related shapes. The artist possesses an uncanny ability to invent biomorphic forms that are as private as her sister *Henriette*'s (p. 33) stiff leg yet universal in their poignant connection with the emotional life and experience of the viewer.

Bourgeois's profoundly psychological sculptures, rooted in the Surrealists' examination of primal impulses, has borne fruit in the work of Rona Pondick. The younger sculptor is both offended and fascinated by the writings of Freud. Her recent work returns us, perhaps unwillingly, to his anal and oral stages of development and asks us to acknowledge, even revel in, these fixations and their associated taboos. Borrowing such standard Freudian fetishes as feces, the breast, and the shoe as subject matter, Pondick shares Bourgeois's remarkable ability simultaneously to provoke, arouse, and repel the viewer. Pondick addresses cultural fears and repressed anxieties concerning sexuality, bodily functions, and traditional gender roles in works that move from the deadly serious to the darkly and comically absurd.

The bed and its myriad and ambivalent associations is the site of a number of Pondick sculptures. Encompassing birth and death, and much that lies in between—sex, illness, pain, dreams, comfort, intimacy, and vulnerability—the bed occupies an enormous niche within our collective psyche. *Double Bed* (p. 37) consists of two thirteen-foot long white vinyl pillows lashed together by a rope grid with numerous baby bottles attached at regular intervals. This pure white island of tranquillity and milky nourishment is violated by occasional black bottles and rope, often associated with bondage. The baby bottle is deftly conflated with the female breast in the sculpture *Milk* (p. 36). Pondick has fashioned two spherical mounds of multiple breast-forms from paper towels and rubber nipples. This profusion of disembodied milk-producing breasts suggests its function as the infant's source of sustenance and its subsequent transformation into an "erotic emblem" by the adult male.[8] Its isolation evokes the fear of loss of the mother in particular and separation anxiety in general. *Milk* is a witty and disturbing symbol of orality, sexuality, bodily function, and gender identification.

Loveseat (p. 36) is one of a recent series of sculptures in which the artist has anthropomorphized various chairs. The seat of this bizarre piece of furniture is shaped like buttocks and covered in lace. Two substantial "legs" wearing men's shoes flank a tiny "leg" wearing a little girl's Mary Jane, its suspension between the "thighs" suggesting male genitals. Elizabeth Hess observes that "this object is anatomically disturbed…Slowly, the family drama on the couch turns out to be about incest. It isn't obvious, just like the crime, but it becomes clear as we sink into this seat."[9] The identification of the shoe both as a surrogate for the body or individual and as a sexual fetish, which is defined by Freud as an object selected as a substitute for the penis, supports this dark interpretation. Pondick's narrative sculptures regularly transgress socially acceptable bounds to expose the primal urge behind the civilized mask.

Sculptor Robert Gober explores the anxieties of childhood and adolescent domestic life in the 1950s and the solitary and vulnerable generation of adults that it spawned. He expresses a longing for the post-World War II ideal of the secure home and family tainted by an understanding of its banality and latent potential

8. Kirby Gookin, *Rona Pondick: Milk, Bed Shoe* (New York: fiction/non-fiction, 1989), unpaginated.

9. Elizabeth Hess, "Nasty Girl," *Village Voice*, May 7, 1991, p. 85.

10. Thomas Pynchon, preface to *Slow Learner, Early Stories* (London: Picador, 1985), cited in Catherine David, "Recent Ruins," in *Robert Gober* (Madrid: Museo Nacional Centro de Arte Reina Sofia, 1992), p. 41.

for emotional and physical violence. Gober's handmade re-creations of household items such as the sink, crib, bed, and armchair depict the commonplace objects that are in intimate, daily contact with the body. They call for its physical presence and evoke feelings of loneliness and loss in its absence. The narrow child's bed, for example, serves as a reminder that one lives, sleeps, and dies all alone. The human perspective conveyed by these inanimate objects is essentially melancholic and morbid, an inventory of the pain and anguish experienced during the course of everyday life. Gober's objects, however, suffer silently, their demeanor is reserved, detached, mute.

The furnishings used by the body have gradually evolved in Gober's recent work into both fragments of the body and hybrid anatomical forms. Like Bourgeois, Pondick, and the Surrealists that preceded them, Gober uses the partial figure to explore human psychology. The traumatic childhood memories informing his domestic objects are more aggressively articulated in his life-sized wax sculptures of isolated legs, torsos, and buttocks and his silkscreened male and female genital wallpaper. The body itself is exposed, and its tentative sexuality and gender uncertainty revealed. A wax candle (p. 41) rising up from its hairy base is an obvious, but impotent phallic symbol. Severed from the body, it implies a violent castration. Gober's startling and improbable half-male, half-female beeswax torso (p. 40) inhabits the form of a crumpled paper bag. Bearing a woman's breast on the left and sprouting men's chest hair on the right, this sack is the embodiment of the genderless being. A torso that is a hybrid of both sexes, neither sex, and a generic paper bag is not designed to establish a clear gender identity. The drawing for Gober's now notorious *Male and Female Genital Wallpaper* (p. 43) was originally commissioned by the Whitney Museum to illustrate the limited edition publication of *Heat* by Joyce Carol Oates. This short story recounts the murder and probable rape of eleven-year-old twin girls. The simple sketch of genitalia and other body parts served as the endpapers for the book which was bound in faux leather and protected by a tiny lock to simulate a young girl's diary. The artist greatly enlarged this once private doodle and silkscreened the image onto wallpaper, enveloping the viewer in a childlike vision of sexuality. Gober demonstrates his subtle sense of humor in lifting graffiti off the outhouse wall and domesticating it as a wallpaper pattern.

Gober's work exposes the pain and oppression experienced in private by the individual, and the implications of this condition on life in the public and political spheres. His dismembered parts—nude, clothed, or inexplicably inscribed with a musical composition—are as opaque as they are unsettling. These are amputations from the social as well as the physical body and reflect a culture built on violence, on exclusion based on difference, that is, "with exceptions thick with indifference, prejudice and fear."[10] He is a fatalist and as such accepts the injustice. He tries, however, to sustain a moral position in the face of the serious and often effective challenges posed to the body and the spirit by a divisive system.

In her various guises as collector, artist, practical woman, trickster, and hawker, French artist Annette Messager examines and critiques Western cultural representations of female identity, intimate relations, sexuality, and power. She photographically dismembers the male and female body, then clusters the tiny black and white images of penises, pubic hair, breasts, nipples, buttocks, noses, and mouths in circles suspended by string or pins them onto dresses. Human identity, once understood as whole and complete, is now perceived only in multiple fragments. In her series *"Mes Voeux (My Wishes)"* (p. 45), a nonhierarchical circular arrangement of bits of the human body, Messager symbolizes the loss of unity, lack of focus, and sense of distintegration that characterizes contemporary life and personal relationships. A sly and witty feminist sensibility underscores all her work. Messager's encyclopedias of isolated body parts also recall the fragmented experience of women juggling the complex daily responsibilities of work, home, and family, as well as the deluge of advertising imagery glorifying the ideally powdered, perfumed, and eroticized (female) body (part). The objectification of the woman's body and demand for conformity to a limited notion of physical beauty, the restrictiveness of her gender role, and exclusion from the power structure by our patriarchal society are the artist's most urgent concerns.

These themes are developed in Messager's recent series *"Histoire des Robes (Story of Dresses)"* (p. 44) which collectively tells a tale of the conventional roles imposed upon women's lives. The dresses themselves, objects of adornment, emphasize the importance of cultivating a lovely appearance "in order to be valued and protected by patriarchy."[11] *Des robes*, pinned with texts, drawings, and photographs, often of the partial body, form a disjointed narrative of equally fetishized body parts. This potentially sensual story is muted by its encasement within a shallow glass box, such that each decorated dress resembles a display of archeological relics or funerary fragments. Messager ironically traces the story of a woman's life through key possessions and tiny photographs while shattering her body and absenting her soul. The prescribed path of womanhood is manifested in the white frocks of youthful innocence, the gorgeous gowns of the young desirable female, the bridal dress connoting the duties of the wife and mother, and finally the black burial shroud. *"Histoire des Robes"* speaks of gender oppression and its assault on the formation of a full human identity.

Kiki Smith is a visceral feminist. She is intimately involved with the "lowly" parts of the human anatomy—internal organs, bodily fluids, and isolated limbs. She valorizes the physical body as our primary means of experiencing the world, revels in its infinite mystery as the vessel of life, and respects its place within nature. At the same time, she acknowledges the body as a political battleground on which the forces of government, religion, and medicine are currently waging war. Like Messager, Smith identifies the female body as the main target of these attacks. Her response, however, is more personal and intimate. She views our broken bodies as the mirror of a highly fragmented society that separates male

11. Annette Hurtig, *Annette Messager: Making Up Stories* (Toronto: Mercer Union, A Centre for Contemporary Visual Arts, 1991), p. 16.

12. Christopher Lyon, "Kiki Smith: Body and Soul," *Artforum*, February 1990, p. 106.

13. Roberta Smith, "Body, Body Everywhere, Whole and Fragmented," *New York Times*, May 15, 1992, section C, p. 24.

from female, mind from body, and body from spirit. Her sculpture is an impassioned attempt to heal or mend these deep divides.

Smith deplores our society's denigration of the body and its functions and urges us to acknowledge and reclaim our corporal being. In an untitled work of 1986 (p. 49), the artist neatly lines up twelve empty glass water bottles bearing the names of various bodily fluids spelled out in the Gothic letters of early science. These large, formidable jars publicly confront us with blood, tears, pus, urine, semen, diarrhea, mucus, saliva, oil, vomit, milk, and sweat, those private fluids that we do our best to cleanse away or hide. This work may embarrass and may also disturb, as we are reminded of the most common path for the transmission of disease. Her most vivid portrayal of bodily fluids consists of a glistening array of more than two hundred six- to eight-inch representations of spermatozoa cast in lead crystal (p. 47). Each piece, individually fondled and imprinted with the artist's fingerprints, is as unique as an actual sperm carrying its specific genetic code. For the artist, sperm is primarily "an incredibly wonderful life force."[12] This delicate and beautiful work invites us to reflect upon the nature of sperm in biology, in sexuality and romance, and in politics, especially in relation to the AIDS epidemic and the struggle over abortion rights.

Most recently the artist has abandoned the life-affirming message of her stream of sperm to create a series of explicitly raw and brutalized wax sculptures of the female nude. To be alive is to experience pain as well as pleasure as these poignant battered women attest. They are debased beings struggling to maintain life and some small shred of humanity even as they crawl on all fours having excreted an impossibly long trail of feces or sit hunched over with deep tears in their backs. *Bloodpool* (p. 51) depicts a bloodied woman curled up in the fetal position, her face a blank, her spinal cord starkly exposed. The bones have literally been ripped from her back intensifying her posture of extreme pain and vulnerability. This tragic work "deals as much with the psychic fragmentation caused by abuse as with the actual violence itself."[13] In viewing this suffering creature we are chastened by the knowledge that a shattered body is the vessel for a shattered spirit.

In his paintings, photographs, installations, performances, and writings, David Wojnarowicz bears witness to the oppression and exclusion of the most socially, sexually, and economically outcast members of our society. His tone is often angry, his imagery apocalyptic. As an abused child, as a homeless teenager who survived as a prostitute in New York's Times Square, and, miraculously, as a visionary artist squarely confronting love and death, Wojnarowicz testifies to the depth and compassion of the human spirit through his anarchistic life and work. Like his friend and former collaborator Kiki Smith, Wojnarowicz uses art aggressively to make the private realm public and to expose the hypocrisy and hidden agendas behind some of the policies of recent Republican administrations and the Catholic Church. The focus of his particular fascination and concern is the gay male

body, as both the object of intense longing and homoerotic desire and of society's virulent and destructive homophobia.

14. Quoted in Lucy R. Lippard, "Out of the Safety Zone," *Art in America*, December 1990, p. 136.

Wojnarowicz attributes the spread of the AIDS epidemic in the gay community in part to our government's lethal lack of support for medical research and to the church's obsolete views on homosexuality and suppression of safe sex information, citing Cardinal O'Connor's preference for "coffins to condoms."[14] The emotional and physical toll and devastating losses wrought by this virus are the primary subjects of the artist's complex, multilayered image and text works, created in the years before his death from AIDS in 1992. The fierce anger and moral outrage of the artist and activist in 1988 became the poetic and philosophical introspection of the dying man only a few years later. *Untitled (for Peter Hujar)* (p. 52) includes nine photographs of the artist Peter Hujar's head, hands, and feet taken by Wojnarowicz just moments after Hujar's death. These serene, almost Christlike images, framed by collaged swimming sperm, a blood-red maze, and U.S. currency, are overlaid with a raging personal diatribe expressing the intense frustration of being HIV positive in the United States. The text reads in part, "I wake up every morning in this killing machine called America and I'm carrying this rage like a blood filled egg and I'm waking up more and more from daydreams of tipping amazonian blowdarts in 'infected blood' and spitting them at the exposed necklines of certain politicians or government healthcare officials or those thinly disguised walking swastika's that wear religious garments over their murderous intentions. . . . I'm a thirty seven foot tall one thousand one hundred and seventy-two pound man inside this six foot frame and all I can feel is the pressure and the need for release."

Wojnarowicz's photograph of the supplicating, filthy bandaged hands of a beggar (*Untitled*, p. 55) implores us to hear the resigned voice of the ailing artist in a text inscribed upon this poignant image. He states, "I can't abstract my own dying any longer. I am a stranger to others and to myself and I refuse to pretend that I am familiar or that I have history attached to my heels. I am glass, clear empty glass. I see the world spinning behind me and through me. . . . I am disappearing. I am disappearing but not fast enough." Wojnarowicz subtitled a series of his published essays a "memoir of disintegration," a prophetic phrase capturing the intensity of a life lived *Close to the Knives*. He explores the body and the spirit in ecstacy and at risk, ravaged and dehumanized by a hostile world and released only through death. He is the perennial outsider with a mission to communicate the hard facts of life on society's fringes.

Sculptors Lilla LoCurto and William Outcault have created a video-installation with an interactive element that explores the nature of the HIV and AIDS epidemic and its potential impact on the general population. Like many struggling to comprehend this perplexing and frightening illness, the artists ask many questions. They wonder whether someone with HIV (human immunodeficiency

virus) could be saved by living in a germ-free environment, but soon learn that a compromised immune system is vulnerable to opportunistic infection both from within the body and from without. As the white blood cells or T cells that fight infection are depleted due to HIV, bacteria and viruses long harbored by the body, or those contracted from external sources, take control of the body and gradually destroy it. Therefore, isolation in a prophylactic bubble could not protect the body from itself.

In *Self-Portrait* (p. 56) LoCurto and Outcault have constructed a transparent sphere symbolizing the human body, replete with a network of vinyl "veins" coursing with blood-red fluid. Four stacked video monitors are mounted within the suspended bubble. The bottom three display changing images of the fragmented figure, progressing upward from the feet and legs to the thighs and pelvis to the chest. The monitors are wrapped in chain link representing the unhealthy body's failed barrier against infection. The willing viewer becomes a visual and visceral component of this installation. The participant sits in a chair before a video camera which transmits an image of his or her head to the top video monitor, completing the fragmented body. The viewer's fingers are placed within a pulse oximeter sensor which is interfaced with an amplifier, speakers, and a pump, making one's heartbeat audible throughout the gallery space and pumping "blood" through the bubble in sychronization with one's pulse. These sensations combined with the sight of one's head atop images of "everyman," enclosed within a vulnerable shell, elicit an inescapable sense of identification with and compassion for those afflicted with AIDS.

The dismemberment of the body in late-twentieth-century art is no accident. It is the result of living in a world in which violence, oppression, social injustice, and physical and psychological stress predominate. We may long for the secure ideals of beauty and wholeness embraced by past generations, but experience tells us that this worldview is obsolete. Synecdoche, when a part is understood to stand in for the whole, is hard-pressed to perform. Wholeness is compromised; the fragment is all. Each day we learn of national borders breaking down, personal rights eroding, and freedom of expression being censored, and these events resonate in our own lives. In the hands of the artists included in *Corporal Politics*, the body fragment metaphorically reveals the multiple challenges confronting the personal and public body today. Robert Gober's torsos and buttocks evoke pervasive feelings of loneliness and loss, Annette Messager's dresses decorated with body parts examine the restrictive conventions shaping woman's lives, and David Wojnarowicz's explosive yet poetic statements identify our government's criminal inactivity in the area of AIDS research and treatment. These are but a few examples of the expressive force of the disintegrated body. Kiki Smith tells us that our intimate and social bodies are in need of healing, and she is right. In order to heal, however, we must pay attention, and in order to pay attention we cannot be ashamed to look.

Helaine Posner is Curator at the MIT List Visual Arts Center.

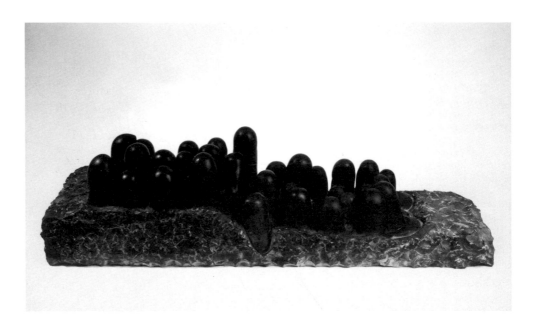

Louise Bourgeois
Untitled, 1990
Black marble
Photograph by Peter Bellamy

facing page
Louise Bourgeois
Henriette, 1985
Bronze
Photograph by Peter Bellamy

With the emotions there is always the physical reaction–the heartbeat, breathing, perspiration. The body always takes part. A while ago I was looking at an early sculpture that I hadn't seen in a long time. The trembling emotions that I felt when I made it came right back. The magic is in the artist's own identification with the work, and that magic brings it back to other people.

To make art is to wake up in a state of craving, a craving to discharge resentment, rage. It's not a linear progression; it goes like a clock; every day, when you reach a certain spot on the clock, it recurs. It's a certain rhythm occurring every day. And the making of art has a curative effect. A tension you are under disappears, dramatically. The making of art is an insight into the source of compulsion, a relief and a deflation of compulsion. Tension builds for an unknown reason, and yet it can be explored. Think of the top coming off a pressure cooker, and the steam releasing; or of the release of sexual tension. Cravings like this, or like the craving for food, may be solved by understanding what they mean. Can you do without chocolate, for example? Perhaps the craving for chocolate is tied to a recollection of a kiss you did not get; the craving was not satisfied, and you feel the painful emotion. Art is the privilege of insight into craving. The craving is not cured, but it is acted out, indulged, and in some way understood.

In my work, I see from the point-of-view of the seducer. The fact that I might be passively seductive doesn't even enter my mind; I am the hunter who actively tries to seduce someone else. Of course, this effort is eternally in vain, but also eternally repeated. I am both the unfortunate seducer and the indefatigable seducer. The fact that I might appear seductive to someone else doesn't even occur to me.

Christiane Meyer-Thoss, *Louise Bourgeois: Designing for a Free Fall* (Zürich: Ammann Verlag AG, 1992), pp. 130–131.

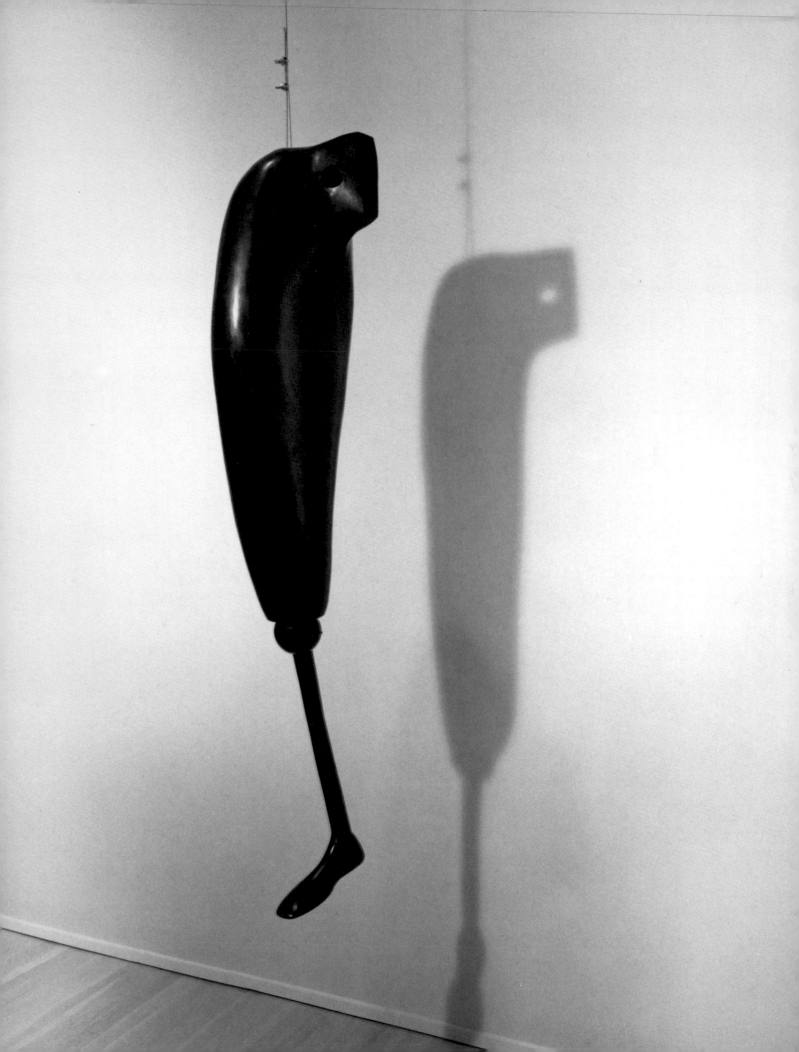

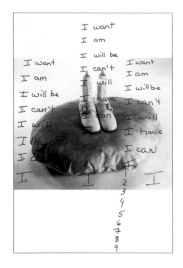

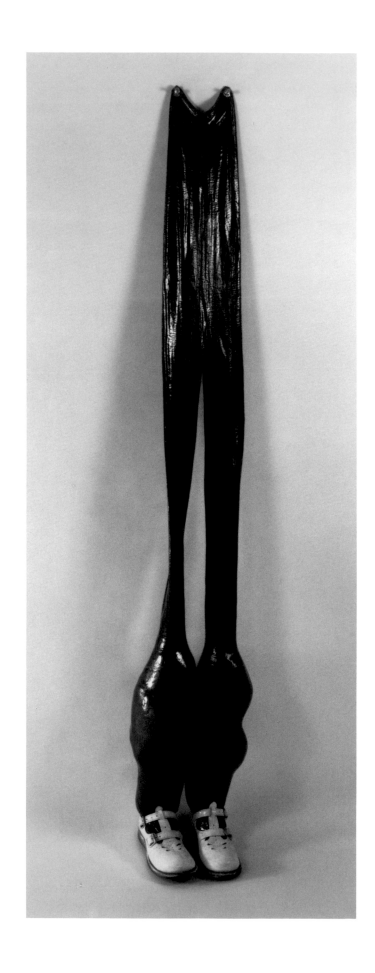

Rona Pondick
Baby Fat, 1991
Tights, polyester stuffing,
shoes, and acrylic resin
Photograph by Jennifer Kotter

facing page
Rona Pondick
Little Bathers, 1990–91 (detail)
Wax, plastic, and rubber teeth
Photograph by Jennifer Kotter

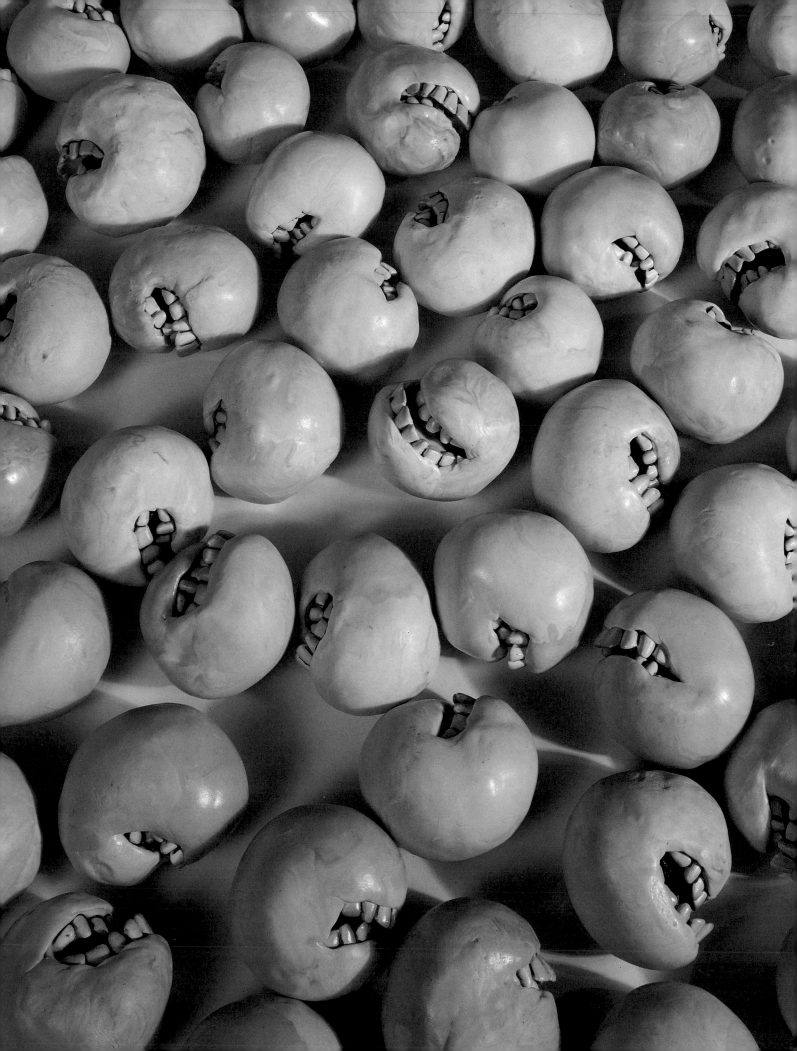

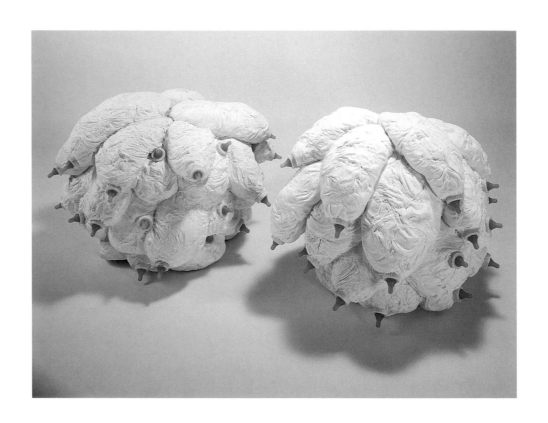

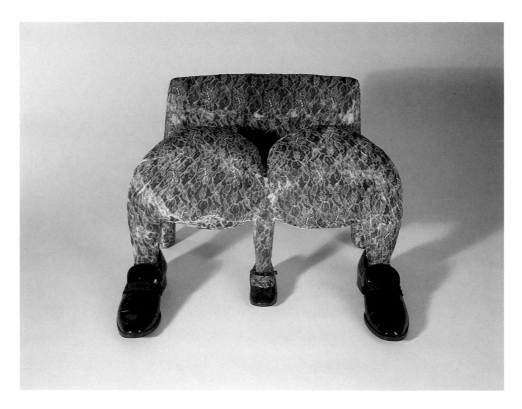

above
Rona Pondick
Milk, 1989
Paper towels, wax, plastic,
and baby bottles
Photograph by Jennifer Kotter

right
Rona Pondick
Loveseat, 1991
Wax, shoes, plastic, wood,
and lace
Photograph by Jennifer Kotter

facing page
Rona Pondick
Double Bed, 1989
Plastic, rope, plastic pillows,
and baby bottles
Photograph by Jennifer Kotter

36

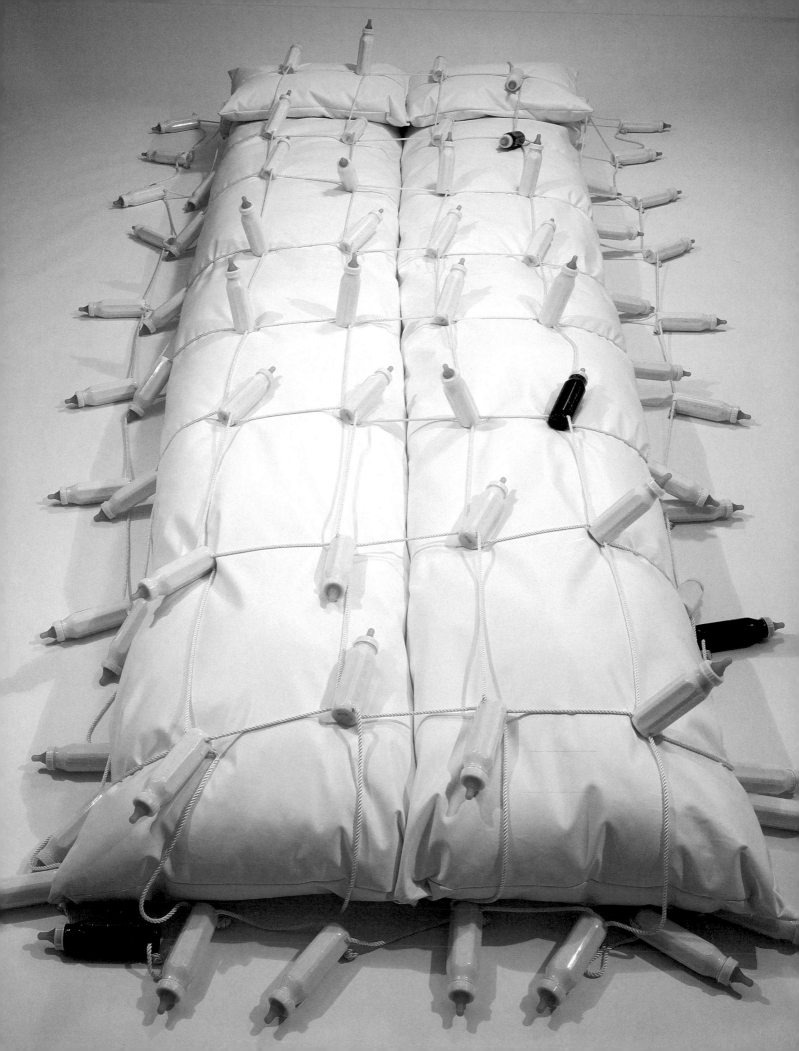

The other day I was working on this sculpture of a leg, which comes out of the wall—I cast my own leg out of beeswax, put a shoe and sock on it, and embedded human hairs in the beeswax—and I remembered that my mother, before she had children, used to work as a nurse in an operating room, and she used to entertain us as kids by telling stories about the hospital. One of her first operations was an amputation, and they cut off the leg and handed it to her. Stories like that made a big impact. But I also realized, looking at this sculpture of a leg that's cut off just above the calf, that it's the sight you see if you glance under a stall in a men's room. You see that portion of a man's identity, and it's very highly charged for one reason or another.

Gary Indiana, "Success: Robert Gober," *Interview*, May 1990, p. 72.

facing page
Robert Gober
Untitled (Leg), 1989
Wax, cotton, wood, leather
shoe, and human hair
Photograph by Lee Stalsworth

page 40
Robert Gober
Untitled, 1990
Beeswax and human hair
Photograph by D. James Dee

page 41
Robert Gober
Untitled (Candle), 1991
Wax and human hair
Photograph by
Geoffrey Clements

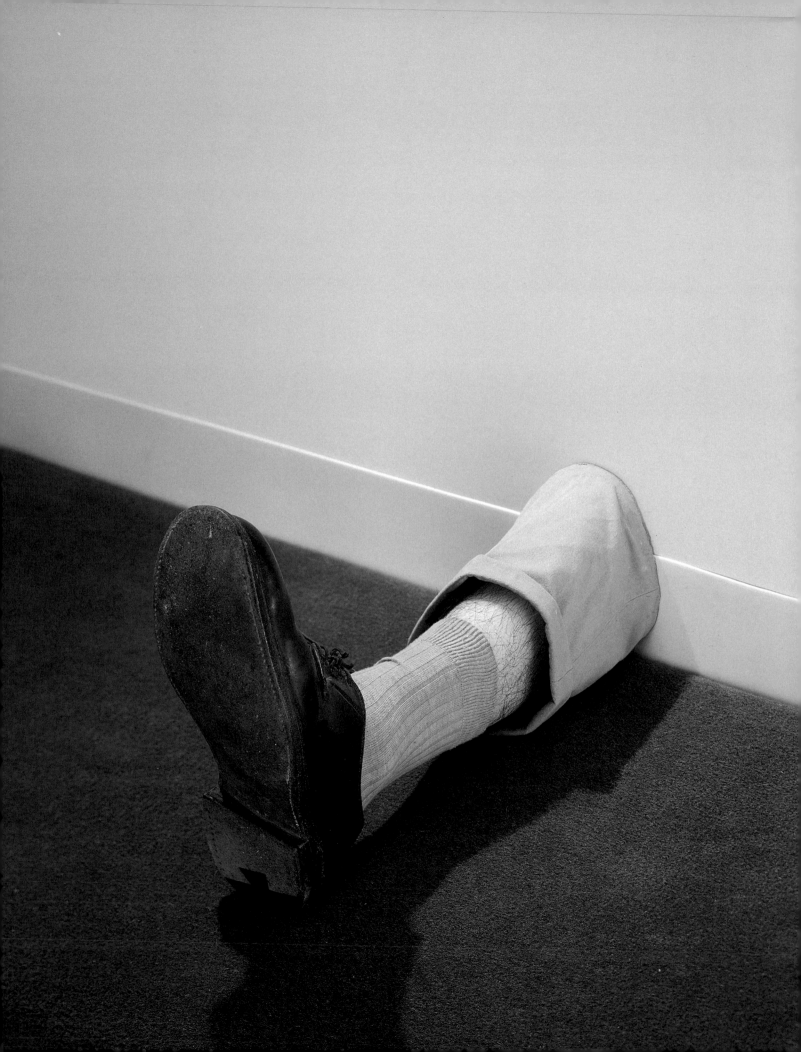

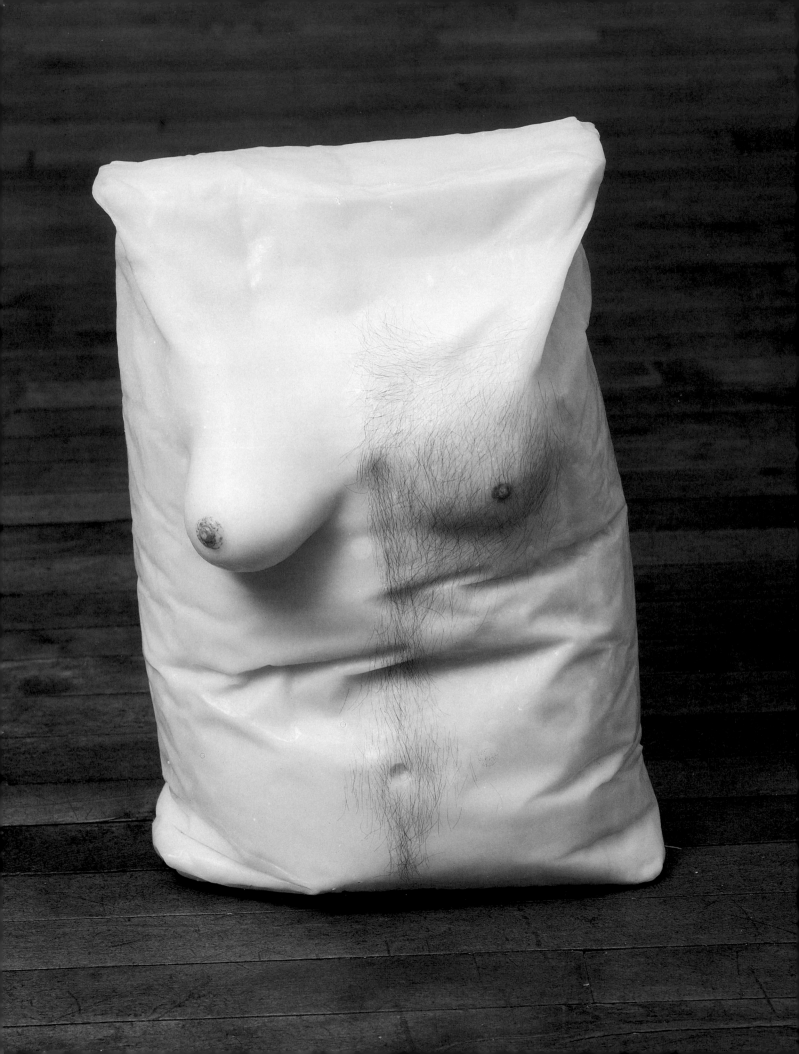

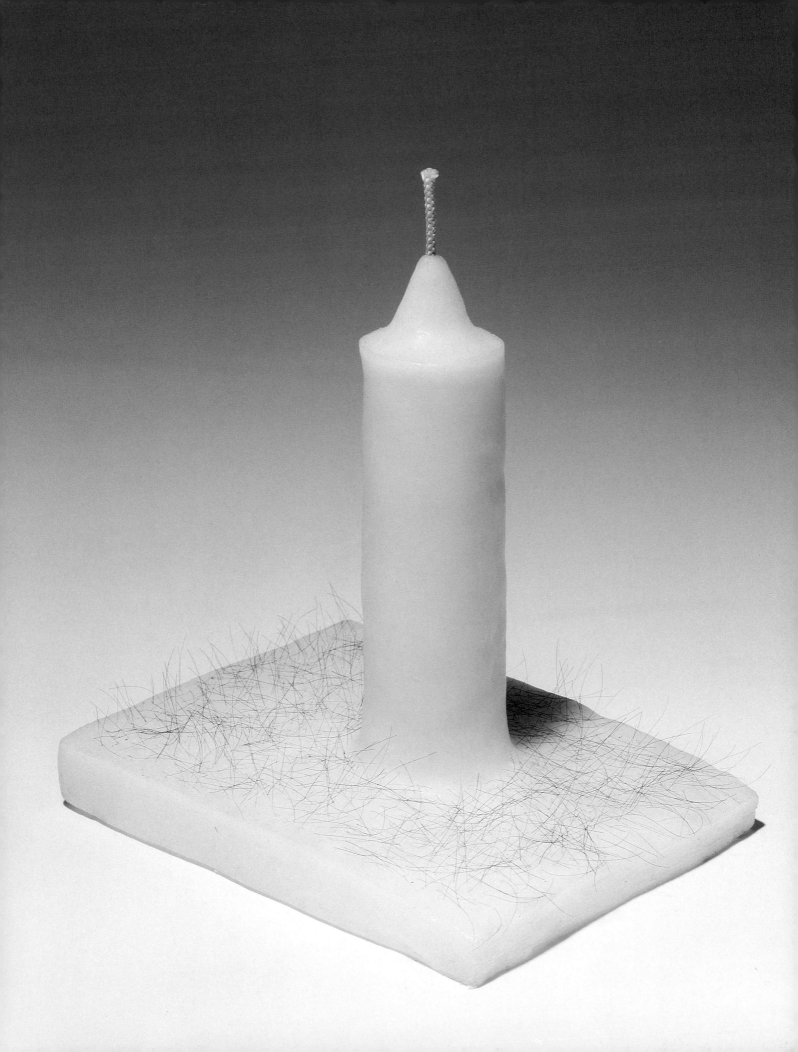

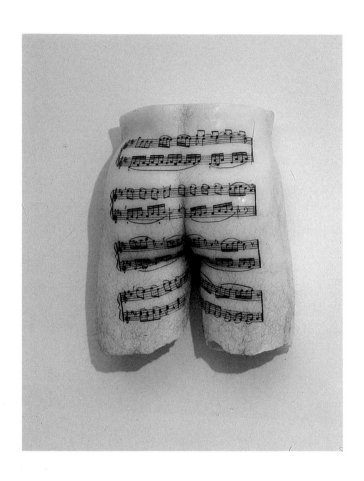

Robert Gober
Untitled, 1990
Wax, wood, oil paint, and human hair

facing page
Robert Gober
Male and Female Genital Wallpaper, 1989
Silkscreen on paper, black version
Photograph by Andrew Moore

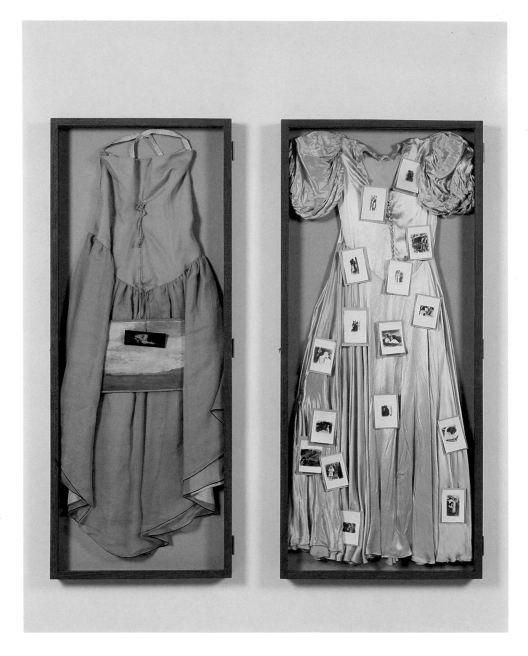

Annette Messager
"Histoire des Robes (Story of Dresses)," 1990
Two dresses, pastel drawing, and black and white photographs in vitrine
Photograph Galérie Crousel-Robelin BAMA, Paris

facing page
Annette Messager
"Mes Voeux (My Wishes)," 1990
250 framed black and white photographs and string
Photograph by André Morin

I feel much closer to the photography of the 19th century, especially medical and judicial uses of photography…my own photographs are posed more often than not, so their context is not "natural", and they are always in black and white…From the very start, photography as a reproductive technique was very closely involved with bodies—with sick bodies and the body as a social phenomenon, with "exotic" bodies and the body as an erotic object…

Photography implies a voyeuristic and, in a way, sadistic relation with the model. This is much less obvious in painting. When you look through the lens, you are peeping through a keyhole.

Annette Messager interviewed by Bernard Marcadé from *Annette Messager: comédie tragédie 1971–1989* (Grenoble: Musée de Grenoble, 1989), pp. 159–160.

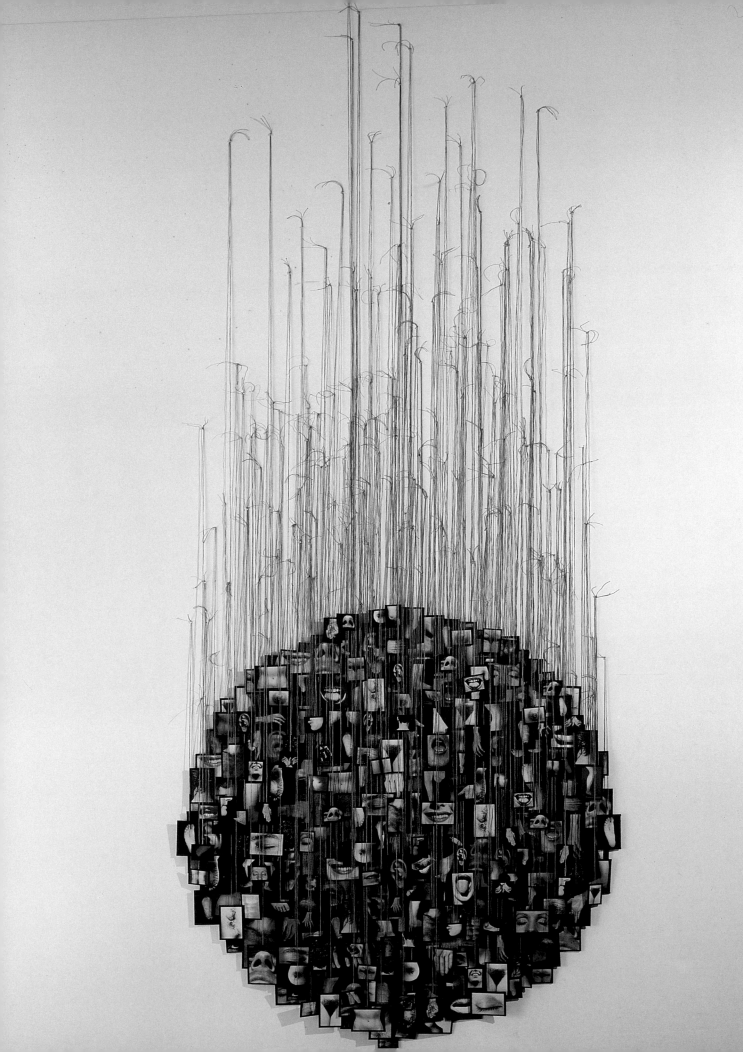

Most of the functions of the body are hidden or separated from society, like sex or bowel movement. Not eating—intake—is still public, I guess. So much is separated from our consciousness or in our consciousness; we separate our bodies from our lives. But, when people are dying, they are losing control of their bodies. That loss of function can seem humiliating and frightening. But, on the other hand, you can look at it as a kind of liberation of the body. It seems like a nice metaphor—a way to think about the social—that people lose control despite the many agendas of different ideologies in society, which are trying to control the body(ies)...medicine, religion, law, etc. Just thinking about control—who has control of the body? does the body have control of itself? do you?—it's kind of schizophrenic, to be separated from the body. Does the mind have control of the body? Does the social?

"An Interview with Kiki Smith" by Robin Winters from *Kiki Smith* (Amsterdam: Institute of Contemporary Art, and The Hague: Sdu Publishers, 1990) p. 127.

facing page
Kiki Smith
Untitled, 1988–90 (detail)
Cast glass
Photograph by Frank Yi

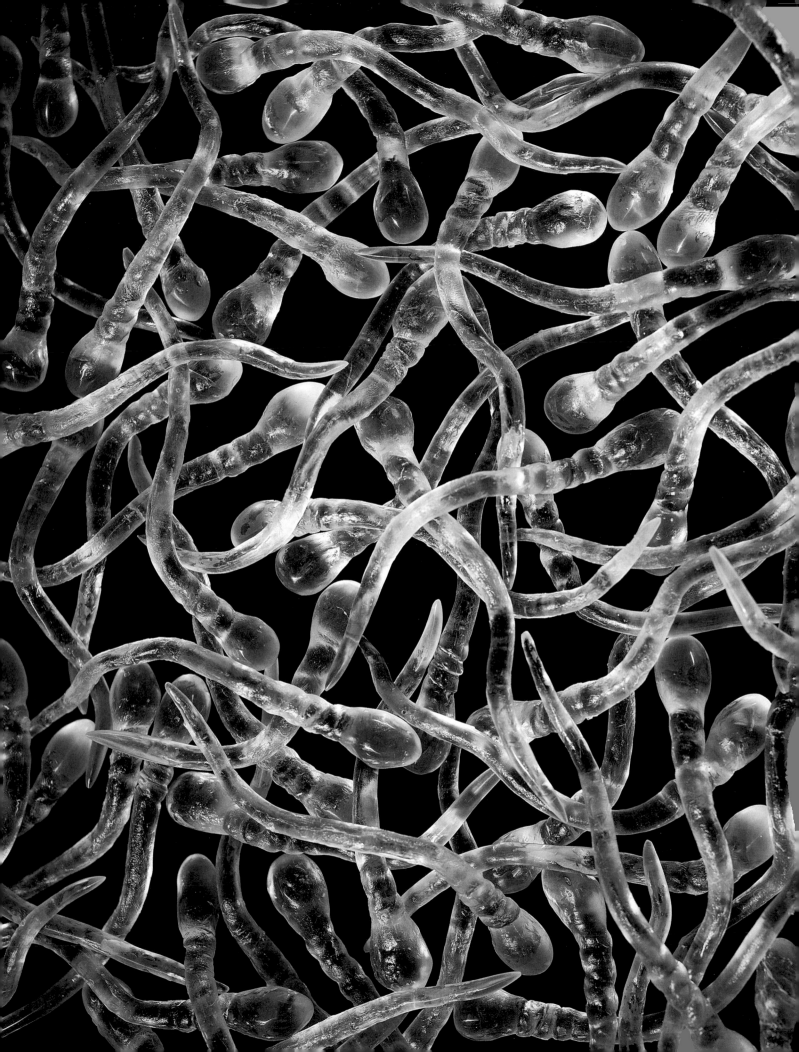

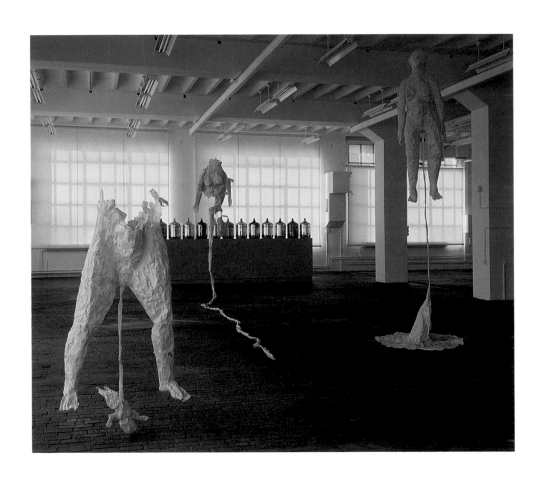

Kiki Smith
Untitled, 1989 (at left)
Paper
Photograph by
Georg Rehsteiner

Kiki Smith
Untitled, 1986
Glass
Photograph by
Nicholas Whitman

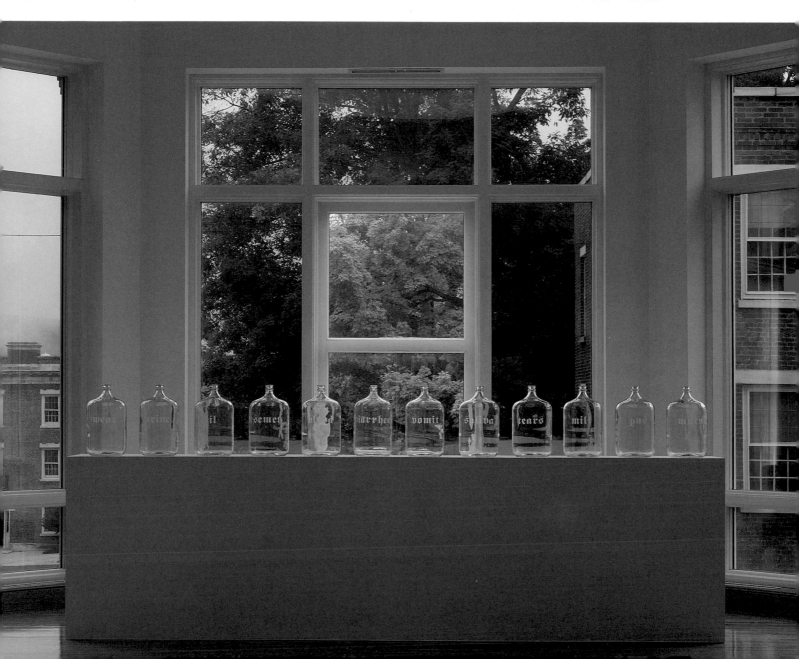

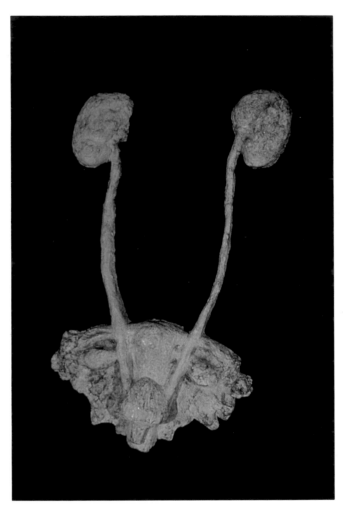 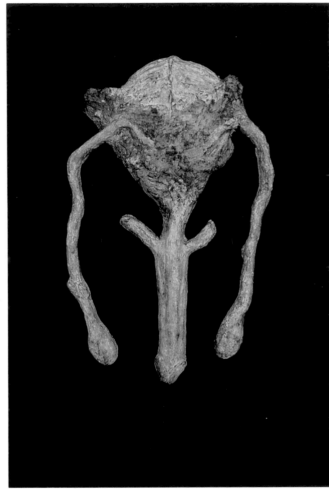

Kiki Smith
Uro-Genital System (female), 1986
Uro-Genital System (male), 1986
Bronze

facing page
Kiki Smith
Bloodpool, 1992
Wax and pigment
Photograph by Tom Warren

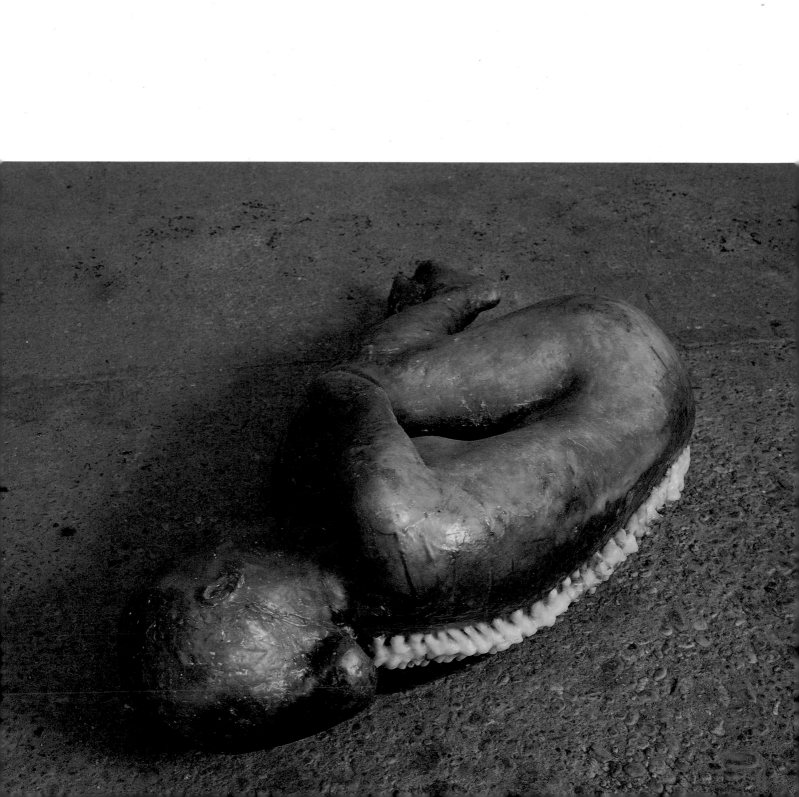

"If I had a dollar to spend for healthcare I'd rather spend it on a baby or innocent person with some defect or illness not of their own responsibility; not some person with Aids..." says the healthcare official on national television and this is in the middle of an hour long video of people dying on camera because they can't afford the limited drugs available that might extend their lives and I can't even remember what this official looked like because I reached in through the t.v. screen and ripped his face in half and I was diagnosed with Arc recently and this was after the last few years of losing count of the friends and neighbors who have been dying slow vicious and unnecessary deaths because fags and dykes and junkies are expendable in this country "If you want to stop Aids shoot the queers..." says the governor of texas on the radio and his press secretary later claims that the governor was only joking and didn't know the microphone was turned on and besides they didn't think it would hurt his chances for re-election anyways and I wake up every morning in this killing machine called america and I'm carrying this rage like a blood filled egg and there's a thin line between the inside and the outside a thin line between thought and action and that line is simply made up of blood and muscle and bone and I'm waking up more and more from daydreams of tipping amazonian blowdarts in 'infected blood' and spitting them at the exposed necklines of certain politicians or government healthcare officials or those thinly disguised walking swastika's that wear religious garments over their murderous intentions or those rabid strangers parading against Aids clinics in the nightly news suburbs there's a thin line a very thin line between the inside and the outside and I've been looking all my life at the signs surrounding us in the media or on peoples lips; the religious types outside st. patricks cathedral shouting to men and women in the gay parade: "You won't be here next year – you'll get Aids and die ha ha..." and the areas of the u.s.a. where it is possible to murder a man and when brought to trial one only has to say that the victim was a queer and that he tried to touch you and the courts will set you free and the difficulties that a bunch of republican senators have in albany with supporting an anti-violence bill that includes 'sexual orientation' as a category of crime victims there's a thin line a very thin line and as each T-cell disappears from my body it's replaced by ten pounds of pressure ten pounds of rage and I focus that rage into non-violent resistance but that focus is starting to slip my hands are beginning to move independent of self-restraint and the egg is starting to crack america seems to understand and accept murder as a self defense against those who would murder other people and its been murder on a daily basis for eight count them eight long years and we're expected to pay taxes to support this public and social murder and we're expected to quietly and politely make house in this windstorm of murder but I say there's certain politicians that had better increase their security forces and there's religious leaders and healthcare officials that had better get bigger dogs and higher fences and more complex security alarms for their homes and queer-bashers better start doing their work from inside howitzer tanks because the thin line between the inside and the outside is beginning to erode and at the moment I'm a thirty seven foot tall one thousand one hundred and seventy-two pound man inside this six foot frame and all I can feel is the pressure all I can feel is the pressure and the need for release

facing page
David Wojnarowicz
Untitled (for Peter Hujar),
1988–89
Acrylic and collage on
masonite
Photograph by Adam Reich

David Wojnarowicz
*Why the Church Can't / Won't Be
Separated from the State or a
Formal Portrait of Culture*, 1990
Acrylic and mixed media
on masonite
Photograph by Adam Reich

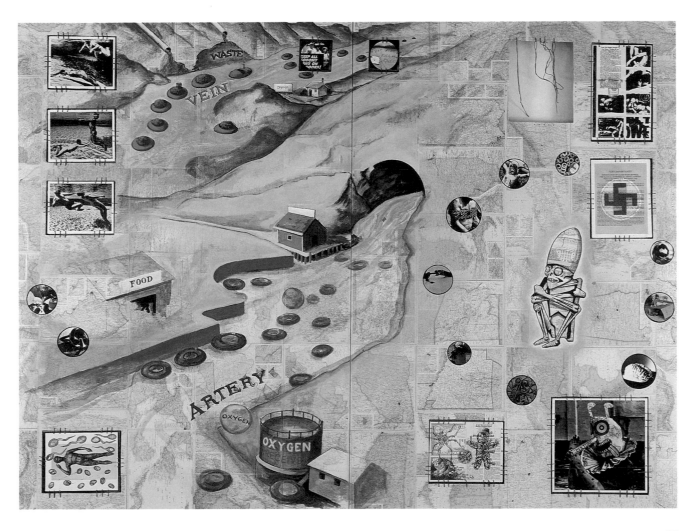

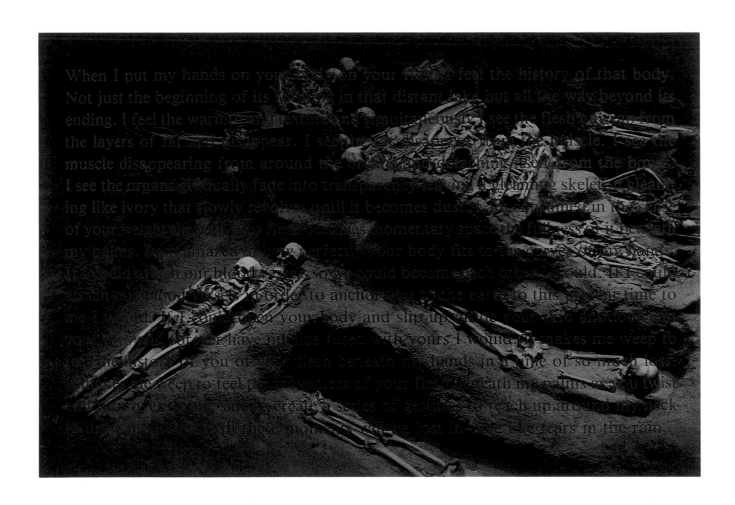

When I put my hands on your body on your flesh I feel the history of that body. Not just the beginning of its formation in that distant lake but all the way beyond its ending. I feel the warmth and texture and simultaneously I see the flesh unwrap from the layers of fat and disappear. I see the fat disappear from around the muscle. I see the muscle disappearing from around the organs and detaching itself from the bones. I see the organs gradually fade into transparency leaving a gleaming skeleton gleaming like ivory that slowly revolves until it becomes dust. I am consumed in the sense of your weight the way your flesh occupies momentary space the fullness of it beneath my palms. I am amazed at how perfectly your body fits to the curves of my hands. If I could attach our blood vessels so we could become each other I would. If I could attach our blood vessels in order to anchor you to the earth to this present time to me I would. If I could open up your body and slip up inside your skin and look out your eyes and forever have my lips fused with yours I would. It makes me weep to feel the history of you of your flesh beneath my hands in a time of so much loss. It makes me weep to feel the movement of your flesh beneath my palms as you twist and turn over to one side to create a series of gestures to reach up around my neck to draw me nearer. All these memories will be lost in time like tears in the rain.

David Wojnarowicz
"When I put my hands on your body," 1990
Silkscreen on silverprint
Photograph by Adam Reich

facing page
David Wojnarowicz
Untitled, 1992
Silkscreen on silverprint
Photograph by Adam Reich

54

Sometimes I come to hate people because they can't see where I am. I've gone empty, completely empty and all they see is the visual form: my arms and legs, my face, my height and posture, the sounds that come from my throat. But I'm fucking empty. The person I was just one year ago no longer exists; drifts spinning slowly into the ether somewhere way back there. I'm a xerox of my former self. I can't abstract my own dying any longer. I am a stranger to others and to myself and I refuse to pretend that I am familiar or that I have history attached to my heels. I am glass, clear empty glass. I see the world spinning behind and through me. I see the calmness and mundane effects of gesture in the constant populations. I look familiar but I am a complete stranger being mistaken for my former selves. I am a stranger and I am moving. I am moving on two legs soon to be on all fours. I am no longer a part of vegetable or mineral. I am no longer made of circuits or disks. I am no longer coded and deciphered. I am all emptiness and futility. I am an empty stranger, a carbon copy of my form. I can no longer find what I'm looking for outside of myself. It doesn't exist out there. It is only in here, inside my head. My head is glass and my eyes have stopped being cameras, the tape has run out and nobody's words can touch me. No gesture can touch me. I've been dropped into all this from another world and I can't speak your language any longer. See the signs I try to make with my hands and fingers. See the useless movements of my lips among the shadows. I am a blank spot in a hectic civilization. I'm a dark smudge in the air that dissipates without notice. I feel like a window, maybe a broken window. I am a glass human. I am a glass human disappearing in rain. I am standing among all of you waving my invisible arms and hands. I am shouting my invisible words. I am getting so weary. I am growing tired. I am waving to you from here. I am crawling and looking for the aperture of complete and final emptiness. I am vibrating in isolation among you. I am screaming but it comes out like pieces of clear ice. I am signalling that the volume of all this is too high. I am waving. I am waving my hands. I am disappearing. I am disappearing but not fast enough.

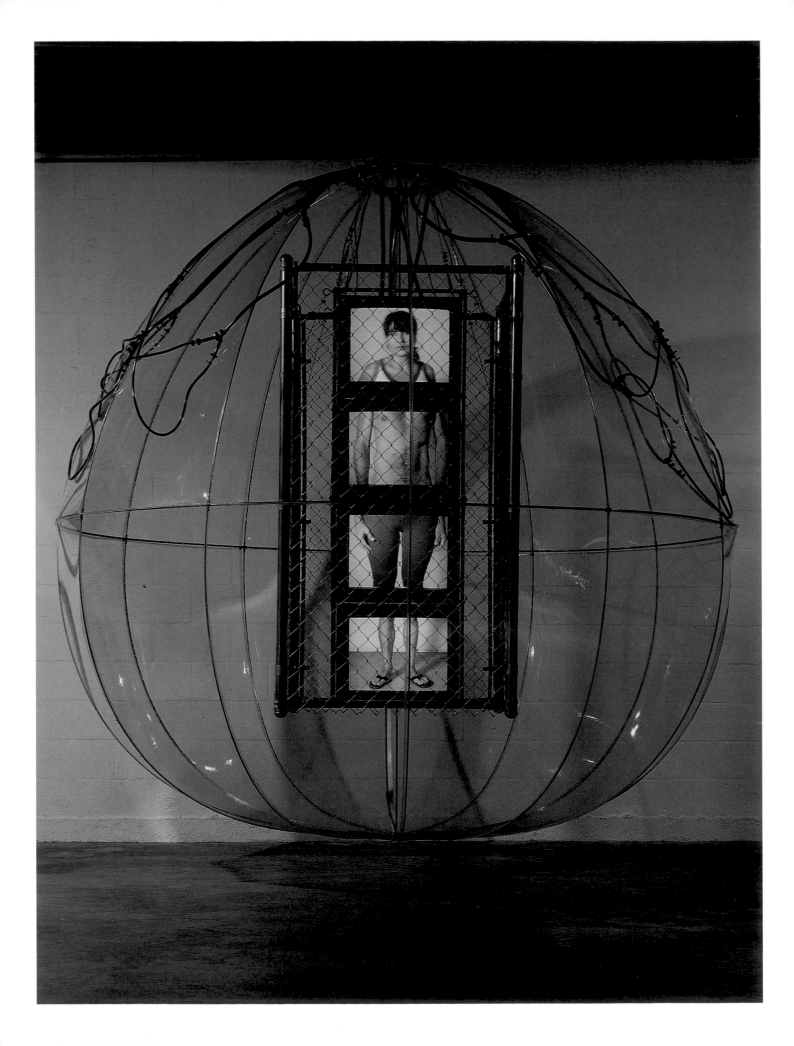

Self-Portrait is a collaborative installation conceived during a conversation in which we asked why our friend, who had recently died of AIDS, couldn't have been saved by being placed in a germ-free environment to guard him from infection. We were told that isolation would be irrelevant because one's body harbors many viruses, which a healthy immune system keeps in check but a compromised immune system allows to run rampant. Therefore, the body becomes its own enemy. *Self-Portrait* deals with this aspect of the disease. We are interested in raising the public's awareness of the mechanics of the HIV virus and how it manifests in the body to shut down the immune system. By engaging the spectator as a component in the installation we hope to graphically convey the virus within.

As a society we were slow to respond to the current epidemic because it seemed at first to effect two rather disenfranchised groups, homosexual men and intravenous drug users. Now that the HIV virus is also flourishing in the heterosexual community we have an excellent example of both the homogeneous nature of late-twentieth-century life and the ironic effect of spitting in the wind.

Self-Portrait incorporates the body in several ways; it is abstracted as a plastic sphere on which "veins" pump "blood," it is presented as videotaped fragments which add up to form a whole figure, and it includes the viewer's own body. A chain link fence wrapped around four stacked video monitors, upon which we see our own video image, represents the compromised immune system. This work is not simply a self-portrait, it also symbolizes the impact of the AIDS epidemic on all of us.

facing page
Lilla LoCurto
and William Outcault
Self-Portrait, 1992
Mixed-media video installation
Photograph by
Robert Wedemeyer

All dimensions are in inches.

LOUISE BOURGEOIS
Henriette, 1985
Bronze
60 x 13 x 12
Courtesy Robert Miller Gallery, New York

LOUISE BOURGEOIS
Untitled, 1990
Black marble
11 1/4 x 45 x 11
Courtesy Robert Miller Gallery, New York

ROBERT GOBER
Male and Female Genital Wallpaper, 1989
Silkscreen on paper, black version
24 x 540 per roll
Courtesy Paula Cooper Gallery, New York

ROBERT GOBER
Untitled (Leg), 1989
Wax, cotton, wood, leather shoe, and human hair
10 3/4 x 20 1/2 x 5 5/8
Hirshhorn Museum and Sculpture Garden,
Smithsonian Institution, The Joseph H. Hirshhorn
Purchase Fund, 1990

ROBERT GOBER
Untitled, 1990
Beeswax and human hair
24 x 15 1/2 x 12
Collection of Lise Spiegel Wilks

ROBERT GOBER
Untitled, 1990
Wax, wood, oil paint, and human hair
18 7/8 x 14 3/4 x 7 1/2
Coleccion Tubacex, Spain

ROBERT GOBER
Untitled (Candle), 1991
Wax and human hair
8 x 4 7/8 x 6 1/2
The Arthur and Carol Goldberg Collection

LILLA LoCURTO and
WILLIAM OUTCAULT
Self-Portrait, 1992
Mixed-media video installation
Dimensions variable
Collection of the artists

ANNETTE MESSAGER
"Mes Trophées (My Trophies)," 1987
Acrylic, charcoal, and pastel on black and white
photograph
35 7/8 x 69 1/4
Collection F.R.A.C. Limousin

ANNETTE MESSAGER
"Mes Voeux (My Wishes)," 1990
250 framed black and white photographs and string
80 diameter
Collection of Michael and Susan Hort

ANNETTE MESSAGER
"Histoire des Robes (Story of Dresses)," 1990
Two dresses, pastel drawing, and black and white
photographs in vitrine
Two parts, 58 1/4 x 22 7/8 x 2 3/4 each
Courtesy Galérie Crousel-Robelin BAMA, Paris

RONA PONDICK
Double Bed, 1989
Plastic, rope, plastic pillows, and baby bottles
9 x 162 x 73
Courtesy fiction/non-fiction, New York and
Asher-Faure Gallery, Los Angeles

RONA PONDICK
Milk, 1989
Paper towels, wax, plastic, and baby bottles
2 parts, 22 x 35 x 32, 22 x 33 x 32
Collection of the artist

RONA PONDICK
Little Bathers, 1990–91
Wax, plastic, and rubber teeth
500 parts, 3 x 3 x 4 each
Collection of Marc and Livia Straus

RONA PONDICK
Baby Fat, 1991
Tights, polyester stuffing, shoes, and acrylic resin
54 x 7 $^1/_2$ x 9 $^1/_2$
Collection of Penny and David McCall

RONA PONDICK
Loveseat, 1991
Wax, shoes, plastic, wood, and lace
17 $^1/_4$ x 21 x 26
Collection of Susan and Peter Straub

KIKI SMITH
Untitled, 1986
Glass
12 jars, 19 $^1/_2$ x 10 x 10 each
Installation dimensions variable
Collection of Gary Rubinstein

KIKI SMITH
Uro-Genital System (female), 1986
Bronze
20 x 11
Courtesy Galérie René Blouin, Montreal

KIKI SMITH
Uro-Genital System (male), 1986
Bronze
16 x 10
Courtesy Galérie René Blouin, Montreal

KIKI SMITH
Untitled, 1988–90
Cast glass
230 parts, 6 to 8 each
Collection Lannan Foundation, Los Angeles

KIKI SMITH
Untitled, 1989
Paper
44 x 6 x 9
Collection of Eileen and Michael Cohen

KIKI SMITH
Bloodpool, 1992
Wax and pigment
42 x 24 x 16
Courtesy of the artist and Fawbush Gallery,
New York

DAVID WOJNAROWICZ
Untitled (for Peter Hujar), 1988–89
Acrylic and collage on masonite
39 x 32
Private Collection

DAVID WOJNAROWICZ
"When I put my hands on your body," 1990
Silkscreen on silverprint
26 x 38
Collection of Tom Rauffenbart

DAVID WOJNAROWICZ
*Why the Church Can't / Won't Be Separated from the State
or a Formal Portrait of Culture*, 1990
Acrylic and mixed media on masonite
96 x 144
The Morton G. Neumann Family Collection

DAVID WOJNAROWICZ
Untitled, 1992
Silkscreen on silverprint
38 x 26
Courtesy of P.P.O.W., New York

Louise Bourgeois

BORN 1911, PARIS
LIVES AND WORKS IN NEW YORK

EDUCATION

Ecole des Beaux-Arts, 1936–1938
Atelier Bissiere, 1936–1937
Ecole du Louvre, 1936–1937
Sorbonne, Paris, 1932–1935

SELECTED ONE-PERSON EXHIBITIONS

1974 *Sculpture 1970–74*, 112 Greene Street,
New York

1979 *Louise Bourgeois: Matrix 17*, University Art
Museum, University of California, Berkeley
(catalog)

1981 *Louise Bourgeois: Femme Maison*,
The Renaissance Society,
University of Chicago (catalog)

1982 *Louise Bourgeois: Retrospective*, Museum of
Modern Art, New York (catalog)

1984 *Louise Bourgeois: Sculpture*, Robert Miller
Gallery, New York

1985 *Louise Bourgeois*, Serpentine Gallery, London
(catalog)

Louise Bourgeois: Retrospektive 1947–1984,
Maeght Lelong, Paris. Traveled to Maeght
Lelong, Zurich (catalog)

1986 *Eyes*, The Doris Freedman Plaza, New York
(catalog)

Robert Miller Gallery, New York (catalog)

1987 *Louise Bourgeois: Paintings from the 1940's*,
Robert Miller Gallery, New York

Louise Bourgeois, The Taft Museum,
Cincinnati

1988 *Louise Bourgeois: Drawings 1939–1987*,
Robert Miller Gallery, New York

1989 *Louise Bourgeois: Works from the Sixties*, Dia Art
Foundation, Bridgehampton, New York

Louise Bourgeois: A Retrospective Exhibition,
Frankfurter Kunstverein, Germany

1990 *Louise Bourgeois: 1984–1989*, Riverside Studios,
London

1991 *Louise Bourgeois: Recent Sculpture*, Robert Miller
Gallery, New York

1992 *C.O.Y.O.T.E.*, Parrish Art Museum,
Southampton, New York

Louise Bourgeois, Milwaukee Art Museum

SELECTED GROUP EXHIBITIONS

1973 *Biennial Exhibition: Contemporary American Art*,
Whitney Museum of American Art, New York

1975 *Sculpture: American Directions*, National
Collection of Fine Arts, Smithsonian
Institution, Washington, D.C.

American Art Since 1945 from the Collection,
Museum of Modern Art, New York

1977 *30 Years of American Art 1945–1975: Selections
from the Permanent Collection*, Whitney Museum
of American Art, New York

1978 *Perspective 1978: Works by Women*, Freedman
Gallery, Albright College, Reading,
Pennsylvania (catalog)

1981 *Decade of Transition 1940–1950*, Whitney
Museum of American Art, New York

1982 *Twenty American Artists: 1982 Sculpture*,
San Francisco Museum of Modern Art

The Human Figure, Contemporary Arts Center,
New Orleans

1983 *1983 Biennial Exhibition*, Whitney Museum of
American Art, New York (catalog)

The Sixth Day, The Renaissance Society,
University of Chicago

1984 *Content: A Contemporary Focus, 1974–1984*,
Hirshhorn Museum and Sculpture Garden,
Smithsonian Institution, Washington, D.C.

Primitivism, Museum of Modern Art,
New York

1985 *Body and Soul: Aspects of Recent Figurative
Sculpture*, Contemporary Arts Center,
Cincinnati

1986 *Individuals: A Selected History of Contemporary
Art, 1945–1986*, Museum of Contemporary
Art, Los Angeles (catalog)

1987 *1987 Biennial Exhibition*, Whitney Museum of
American Art, New York (catalog)

1988 *Figure as Subject: The Revival of Figuration Since
1975*, Whitney Museum of American Art,
New York

1989 *Magiciens de la Terre*, Musée National d'Art Moderne-Centre Georges Pompidou, Paris

Bilderstreit, Museum Ludwig, Cologne

Prospect 89, Frankfurter Kunstverein, Germany

1990 *Inaugural Exhibition Part II, Art in Europe and America: The 1960s and 1970s*, Wexner Center for the Visual Arts, Columbus, Ohio

Figuring the Body, Museum of Fine Arts, Boston

1991 *Carnegie International*, Carnegie Museum of Art, Pittsburgh

Pulsio, Fundacio Caixa de Pensiones, Barcelona

Die Hand Des Künstlers, Museum Ludwig, Cologne

Dislocations, The Museum of Modern Art, New York

1992 *Documenta IX*, Kassel, Germany

From Brancusi to Bourgeois: Aspects of the Guggenheim Collection, Guggenheim Museum Soho, New York

SELECTED BIBLIOGRAPHY

1975 Lippard, Lucy R. "Louise Bourgeois: From the Inside Out," *Artforum*, March 1975, pp. 26–33.

1978 Ratcliff, Carter. "Louise Bourgeois," *Art International*, November/December 1978, pp. 26–27.

1979 Russell, John. "The Sculpture of Louise Bourgeois," *New York Times*, October 5, 1979, p. C21.

1980 Gardner, Paul. "The Discreet Charm of Louise Bourgeois," *Artnews*, February 1980, pp. 80–86.

Kramer, Hilton. "Art: Contrasts in Imagery, 2 Views of Louise Bourgeois," *New York Times*, October 3, 1980, p. C29.

1982 Glueck, Grace. "Louise Bourgeois, a Life in Sculpture, at Modern Museum," *New York Times*, November 5, 1982, pp. C1, C18.

Brenson, Michael. "A Sculptor Comes Into Her Own," *New York Times*, October 31, 1982, p. H29.

1983 Ratcliff, Carter. "New York: Louise Bourgeois at the Museum of Modern Art," *Flashart*, January 1983, p. 62.

1984 Thurman, Judith. "Artist's Dialogue, Passionate Self-Expression—The Art of Louise Bourgeois," *Architectural Digest*, November 1984, pp. 234–246.

1987 Kuspit, Donald. "Louise Bourgeois—Where Angels Fear To Tread," *Artforum*, March 1987, pp. 115–120.

1988 Morgan, Stuart. "Taking Cover; Louise Bourgeois" (interview), *Artscribe*, January/February 1988, pp. 30–34.

Gardner, Paul. "Louise Bourgeois Makes A Sculpture," *Artnews*, Summer 1988, pp. 61–64.

1989 Kirili, Alain. "The Passion For Sculpture—A Conversation with Louise Bourgeois," *Arts Magazine*, March 1989, pp. 68–75.

1990 Bourgeois, Louise. "Freud's Toys," *Artforum*, January, 1990 pp. 111–113.

Brenson, Michael. "For Louise Bourgeois at 79, Honor in Her Homeland at Last," *New York Times*, August 6, 1990, pp. C11–C12.

1991 Heymer, Kay. "Louise Bourgeois/Long Standing Singular Figure," *Flashart*, May/June 1991, p. 135.

Various authors. "Collaboration: Louise Bourgeois/Robert Gober," *Parkett*, no. 27, March 1991, pp. 28–105.

Treat, Carolyn. "Louise Bourgeois: 'Art is a Guarantee for Sanity,'" *Kunst & Museum Journaal*, volume 2, no. 6, 1991, pp. 54–57.

Gopnik, Adam. "The Art World," *The New Yorker*, November 25, 1991, pp. 110–120.

1992 Danto, Arthur. "Art. Dislocationary Art." *The Nation*, January 6/13, 1992, pp. 29–32.

Kimmelman, Michael, "Louise Bourgeois Comes Into Her Own at 80," *New York Times*, August 30, 1992, section 2, pp. 1, 27.

Louise Bourgeois has exhibited her work internationally since 1936. This abridged biography and bibliography lists only exhibitions and periodical references from the past twenty years.

Robert Gober

BORN 1954, WALLINGFORD,
CONNECTICUT
LIVES AND WORKS IN NEW YORK

EDUCATION

BA, Middlebury College, Middlebury, VT, 1976
Tyler School of Art, Rome, Italy, 1973–74

SELECTED ONE-PERSON EXHIBITIONS

1984 Paula Cooper Gallery, New York

1985 Daniel Weinberg Gallery, Los Angeles
 Paula Cooper Gallery, New York

1986 Daniel Weinberg Gallery, Los Angeles

1987 Galerie Jean Bernier, Athens (catalog)
 Paula Cooper Gallery, New York

1988 Tyler Gallery, Tyler School of Art, Temple
 University, Elkins Park, Pennsylvania
 (catalog)

 The Art Institute of Chicago (catalog)

 Galerie Max Hetzler, Cologne

 Galerie Gisela Capitain, Cologne

1989 Paula Cooper Gallery, New York

1990 Museum Boymans-van Beuningen,
 Rotterdam. Traveled to Kunsthalle, Bern
 (catalog)

 Galeria Marga Paz, Madrid

1991 Galérie Nationale du Jeu de Paume, Paris.
 Traveled to the Museo Nacional Centro de
 Arte Reina Sofia, Madrid (catalog)

1992 *Robert Gober*, Dia Center for the Arts,
 New York

SELECTED GROUP EXHIBITIONS

1986 *Objects from the Modern World:
 Richard Artschwager, R.M. Fischer, Robert Gober,
 Jeff Koons*, Daniel Weinberg Gallery,
 Los Angeles

 *New Sculpture: Robert Gober, Jeff Koons,
 Haim Steinbach*, The Renaissance Society,
 Chicago (catalog)

1987 *Avant-Garde in the Eighties*, Los Angeles
 County Museum of Art (catalog)

 New York Art Now: The Saatchi Collection
 (Part I), The Saatchi Collection, London
 (catalog)

1988 *Utopia Post Utopia: Configurations of Nature and
 Culture in Recent Sculpture and Photography*,
 Institute of Contemporary Art, Boston
 (catalog)

 New York Art Now: The Saatchi Collection
 (Part II), The Saatchi Collection, London
 (catalog)

 *La Biennale di Venezia: XLIII Esposizione
 International d'Arte 1988*, Venice (catalog)

 The Binational: American Art of the Late 80s,
 Museum of Fine Arts and Institute of
 Contemporary Art, Boston. Traveled to
 Kunsthalle, Dusseldorf (catalog)

1989 *Horn of Plenty*, Stedelijk Museum,
 Amsterdam

 1989 Biennial Exhibition, Whitney Museum of
 American Art, New York (catalog)

1990 *Culture and Commentary: An Eighties Perspective*,
 Hirshhorn Museum and Sculpture Garden,
 Smithsonian Institution, Washington, D.C.
 (catalog)

 New Work: A New Generation, San Francisco
 Museum of Modern Art (catalog)

1991 *Metropolis*, Martin-Gropius-Bau, Berlin

 1991 Biennial Exhibition, Whitney Museum of
 American Art, New York (catalog)

 *Selections From the Elaine and Werner
 Dannheisser Collection: Painting and Sculpture
 From the 80s and 90s*, Parrish Art Museum,
 Southampton, NY (catalog)

SELECTED BIBLIOGRAPHY

1985 Decter, Joshua. "Robert Gober,"
 Arts Magazine, December 1985, p. 124.

1986 Collins, Tricia, and Richard Milazzo.
 "The Subliminal Function of Sinks,"
 Artforum, June/August 1986, pp. 320–322.

1987 Indiana, Gary. "The Torture Garden,"
 Village Voice, October 27, 1987, p. 105.

Princenthal, Nancy. "Robert Gober at Paula Cooper," *Art in America*, December 1987, pp. 153–154.

1988 Rubenstein, Meyer Raphael, and Daniel Weiner. "Spotlight: Robert Gober," *Flash Art*, January/February 1988, p. 119.

Joselit, David. "Investigating the Ordinary," *Art in America*, May 1988, pp. 148–154.

1989 Koether, Jutta. "Robert Gober," *Artforum*, February 1989, p. 145.

Gober, Robert. "Cumulus," *Parkett*, no. 19, 1989, pp. 169–171.

Sherlock, Maureen P. "Arcadian Elegy: The Art of Robert Gober," *Arts Magazine*, September 1989, pp. 44–49.

Sundell, Margaret. "Robert Gober," *Seven Days*, October 18, 1989, p. 73.

Smith, Roberta. "The Reinvented Americana of Robert Gober's Mind," *New York Times*, October 13, 1989, p. C28.

Gholson, Craig. "Robert Gober," *Bomb*, Fall 1989, pp. 32–37.

Liebman, Lisa. "The Case of Robert Gober," *Parkett*, no. 21, 1989, pp. 6–9.

Saltz, Jerry. "Notes on a Sculpture," *Arts Magazine*, December 1989, p. 22.

1990 Weinstein, Matthew. "The House of Fiction," *Artforum*, February 1990, pp. 128–132.

Flood, Richard. "Robert Gober: Special Editions, An Interview," *Print Collector's Newsletter*, March/April 1990, pp. 6–9.

Indiana, Gary. "Success: Robert Gober," *Interview*, May 1990, p. 72.

Jones, Bill. "Stunted Brides and Fascinating Hardware," *Arts Magazine*, Summer 1990, pp. 56–60.

1991 Various authors. "Collaboration: Louise Bourgeois/Robert Gober," *Parkett*, no. 27, March 1991, pp. 28–105.

Schjeldahl, Peter. "Cutting Hedge," *Village Voice*, April 30, 1991, pp. 93–94.

Danto, Arthur C. "Art for Activism's Sake," *The Nation*, June 3, 1991, pp. 743–747.

1992 Criqui, Jean-Pierre, *Artforum*, January 1992, pp. 115–116.

Lilla LoCurto

BORN 1949, SAN FRANCISCO DE MACAIRA, VENEZUELA

LIVES IN LOS ANGELES

EDUCATION

MFA, Southern Illinois University, Carbondale, 1978

Accademia di Belle Arti, Rome, 1973–1975

BFA, Arizona State University, Tempe, 1973

SELECTED EXHIBITIONS

1981 *Sculpture Invitational*, Riverside Art Center and Museum, California

1984 Mekler Gallery, Los Angeles

1986 Gallery 454 North, Los Angeles (one-person)

Small-Scale Sculptural Interpretations of Urban Landscape, Fisher Gallery, University of Southern California, Los Angeles (catalog)

1987 *3 Exhibitions*, Occidental College, Los Angeles

Contemporary Bronze, California State University, San Bernardino

1988 *Present Tense*, Los Angeles County Municipal Art Gallery

Molten Metal, Security Pacific Gallery at the Plaza, Los Angeles

1990 *Forbidden Entry*, Fisher Gallery, University of Southern California, Los Angeles (catalog)

1991 *Crossings*, Santa Monica Museum of Art, California (one-person)

Critical Reactions, Rena Bransten Gallery, San Francisco

Ovsey Gallery, Los Angeles (one-person)

1992 *Oddly*, The Oakland Museum (catalog)

Saddleback College Art Gallery, Mission Viejo, California (with William Outcault)

SELECTED BIBLIOGRAPHY

1990 Buimer, Marge. "Forbidden Entry," *ArtScene*, September 1990, p. 20.

O'Brien, John. "Room with a View 2," *Visions Art Quarterly*, Winter 1990.

William Outcault

1991 Brumer, Andy. "Lilla LoCurto," *ArtScene*, July/August 1991, pp. 17–18.

Laurence, Michael. "Mr. Rogers' Objecthood," *Visions Art Quarterly*, Winter 1991, p. 34.

Geer, Suvan. "Crossings," *Los Angeles Times*, July 23, 1991, p. 4 pt. F.

1992 Breslin, Ramsey Bell. "Oddly: Works by Four Los Angeles Artists," *Express Berkeley*, June 3, 1992.

Bonetti, David. "Sculptors Who Attract, Oddly Enough," *San Francisco Examiner*, June 11, 1992, p. C1.

Fowler, Carol. "'Oddly', Art Makes Points That Can Hurt," *Contra Costa Times*, May 29, 1992, p. 11.

Maclay, Catherine. "Ambiguity and Amusement from Four Los Angelenos," *San Jose Mercury News*, May 22, 1992, p. 48

BORN 1949, NEPTUNE, NEW JERSEY
LIVES IN LOS ANGELES

EDUCATION

MFA, Southern Illinois University, Carbondale, 1978

BFA, Mankato State University, Minnesota, 1976

SELECTED EXHIBITIONS

1983 Installation Gallery, San Diego

1985 Roger Morrison Gallery, Los Angeles

1987 Gallery 454 North, Los Angeles (one-person)

3 Exhibitions, Occidental College, Los Angeles

Contemporary Bronze, California State University, San Bernardino

1988 *Molten Metal*, Security Pacific Gallery at the Plaza, Los Angeles

1989 *Sculptural Intimacies*, Security Pacific Gallery, Costa Mesa, California (catalog)

No Stomach, Installation Gallery, San Diego

1992 Saddleback College Art Gallery, Mission Viejo, California (with Lilla LoCurto)

SELECTED BIBLIOGRAPHY

1988 Byer, Robert. "Sculptural Transmutations," *Artweek*, June 25, 1988, vol. 19, pp. 5–6.

1989 O'Brien, John. "Sculptural Intimacies," *Artweek*, December 28, 1989, pp. 12–13.

Curtis, Cathy. "Case Made for Smallness by 'Sculptural Intimacies,'" *Los Angeles Times*, December 27, 1989, p. 3.

1992 Brumer, Andy. "William Outcault," *Artspace*, November/December 1992.

Bulmer, Marge. "William Outcault," *Visions Art Quarterly*, Fall 1992, p. 60.

Annette Messager

BORN 1943, BERCK-SUR-MER, FRANCE
LIVES AND WORKS IN PARIS

SELECTED ONE-PERSON EXHIBITIONS

1982 Artists Space, New York

1983 Musée des Beaux-Arts, Calais

1984 ARC-Musée d'Art Moderne de la Ville de Paris

1985 Riverside Studios, London

 Galérie Gillespie-Laage-Salomon, Paris

1986 Galérie d'Art Contemporain des Musées de Nice

1987 Vancouver Art Gallery

 Art Space of Sydney

1988 Galérie Laage-Salomon, Paris

 Le Consortium, Dijon

 Centre d'art Contemporain, Castres

1989 *Mes Enluminures*, Galérie Crousel-Robelin BAMA (Nuits Beaubourg), Paris

 Mes ouvrages, Eglise Saint-Martin du Méjan, Arles (catalog)

 Annette Messager: comédie tragédie 1971–1989, Musée de Grenoble. Traveled to Kunstverein, Bonn; Musée Municipale, La Roche-sur-Yon, France; and Kunstverein für die Rheinlande und Westfalen, Düsseldorf (catalog)

1990 Galérie Crousel-Robelin BAMA, Paris

 Galerie Elizabeth Kauffmann, Zurich

1991 *Making Up Stories*, Mercer Union, A Centre for Contemporary Visual Art, and Cold City Gallery, Toronto. Traveled to Mendel Art Gallery, Saskatoon; Presentation House Gallery; and Contemporary Art Gallery, Vancouver (catalog)

1992 The University of Iowa Museum of Art, Iowa City (catalog)

SELECTED GROUP EXHIBITIONS

1976 *La Biennnale di Venezia: Esposizione International d'Arte 1976*, Venice (catalog)

1977 *Bookworks*, The Museum of Modern Art, New York

 Bienniale de Paris

 Documenta VI, Kassel, Germany

1979 *European Dialogue, The 1st Annual Sydney Biennial*, Art Gallery of New South Wales

 Photography as Art, Institute of Contemporary Art, London

 Tendances de l'art en France III, 1968–1978/ 1979, Partis-pris autres, ARC-Musée d'Art Moderne de la Ville de Paris

1982 *Art d'Aujourd'hui et Erotisme*, Kunstverein, Bonn

 Statements 1, Holly Solomon Gallery, New York

1983 *New Art 83*, Tate Gallery, London

 Kunst mit Photographie, Nationalgalerie, Berlin. Traveled to Kunstverein, Cologne, and Kunsthalle, Keil

1984 *The 6th Annual Sydney Biennial*, Art Gallery of New South Wales

1985 *Dialog*, Moderna Museet, Stockholm

 Livres d'Artistes, Musée National d'Art Moderne-Centre Georges Pompidou, Paris

1986 *Régional d'Art Contemporain Rhône-Alpes*, le Magasin, Centre National d'Art Contemporain, Grenoble

 Photography as Performance, The Photographers' Gallery, London

1987 *Exotische Welten, Europaïsche Phantasien*, Kunstverein, Stuttgart

1988 *Auf zwei hochzeiten tanzen*, Kunsthalle, Zurich

 Narrative Art, Fonds Régional d'Art Contemporain de Bourgogne, Dijon

1989 *Les 100 jours d'art contemporain de Montréal*, Centre International d'art Contemporain, Montréal

 L'invention d'un art, Musée National d'Art Moderne-Centre Georges Pompidou, Paris

1990 *Photographic Representation in the Eighties, Images in Transition*, The National Museum of Modern Art, Kyoto; The National Museum of Modern Art, Tokyo.

The 12th Annual Sydney Biennial, Art Gallery of
New South Wales

1991 *Biennale de Sao Paulo*, Brazil

Individualities: Fourteen Artists from France,
Art Gallery of Ontario, Toronto

1992 *Parallel Visions: Modern Artists and Outsider Art*,
Los Angeles County Museum of Art

Annette Lemieux and Annette Messager, Josh Baer
Gallery, New York

SELECTED BIBLIOGRAPHY

1986 Whiles-Serreau, Virginia. "Annette Messager,"
Artscribe, December 1985/January 1986.

1988 Paini, Dominique. *Flash Art*, October 1988,
p. 142.

Soutif, Daniel. *Artforum*, October 1988,
pp. 160–161.

1989 Adams, Brooks. "The Museum as Studio,"
Art in America, October 1989, p. 63.

1990 Gourmelon, Mo. "Arbitrated Dissections:
The Art of Annette Messager," *Arts Magazine*,
November 1990, pp. 66–71.

McKenna, Kristine. "A Contemporary
Assemblage of Politics, Desire,"
Los Angeles Times, August 21, 1990, p. 4 pt. F.

Pohlen, Annelie. "The Utopian Adventures of
Annette Messager," *Artforum*, September
1990, pp. 111–116.

1991 Adams, Brooks. *Art in America*, January 1991,
p. 145.

Kandel, Susan. "History as Fiction,
A Provocative Show," *Los Angeles Times*,
August 29, 1991, p.12 pt. F.

Romano, Gianni. "Talk Dirt: Interview with
Annette Messager," *Flash Art*, Summer 1991,
p. 102.

Troncy, Eric. "Annette Messager: From
Statements on a Life of Mediocrity to the
Wondrous Postulates of Fictions," *Flash Art*,
Summer 1991, pp. 103–105.

1992 Hurtig, Annette. *Flash Art*, January/February
1992, p. 162.

Rona Pondick

BORN 1952, BROOKLYN, NEW YORK
LIVES AND WORKS IN NEW YORK

EDUCATION

MFA, Yale University School of Art, New Haven,
Connecticut, 1977

BFA, Queens College, Queens, New York, 1974

SELECTED ONE-PERSON EXHIBITIONS

1988 Sculpture Center, New York (catalog)

fiction/nonfiction, New York

1989 *Bed Milk Shoe*, fiction/nonfiction, New York
(catalog)

Hillman Holland Gallery, Atlanta

Currents, Institute of Contemporary Art,
Boston

1990 *mamamamama*, Asher-Faure Gallery,
Los Angeles

1991 Asher-Faure Gallery, Los Angeles

Foot and Mouth, fiction/nonfiction (catalog)

Scrap, Beaver College Art Gallery, Glenside,
Pennsylvania (catalog)

1992 The Israel Museum, Jerusalem (catalog)

Galérie Thaddaeus Ropac, Paris

Transepoca, Milan

SELECTED GROUP EXHIBITIONS

1984 *Exceptional and New*, Rosa Esman Gallery,
New York

1985 *The Non-Objective World*, alternative space,
New York

1986 *Emerging Sculptors: 1986*, Sculpture Center,
New York (catalog)

1987 *The Level of Volume*, Carl Solway Gallery,
Cincinnati

*Peter Flaccus, Helen Miranda Wilson and
Rona Pondick*, Zabriskie Gallery, New York

Small Works, Sculpture Center, New York

1988 *Girls Night Out (Femininity as Masquerade)*,
The New Museum of Contemporary Art,
New York

Sculpture 1988: A Salon of Small-Scale Work,
White Columns, New York

*The Other New York: Sculpture by
Maureen Connor, Rona Pondick and Kate Ritson,*
Galerie Alfred Kren, Cologne

1989 *Erotophobia: A Forum in Contemporary
Sexuality,* Simon Watson Gallery, New York

Form and Fetish, Emily Sorkin Gallery,
New York

*Lines of Vision: Drawings by Contemporary
Women,* BlumHelman Gallery, New York
(catalog)

1990 *Fragments, Parts and Wholes: The Body and
Culture,* White Columns, New York

Detritus: Transformation and Re-Construction,
Jack Tilton Gallery, New York

The Body, Once Removed, Emily Sorkin Gallery,
New York

The Home Show, Asher-Faure Gallery,
Los Angeles (catalog)

1991 *1991 Biennial Exhibition,* The Whitney
Museum of American Art, New York
(catalog)

Plastic Fantastic Lover (Object A), BlumHelman
Warehouse, New York (catalog)

1992 *Powerplay,* School of the Art Institute of
Chicago

*The Whole Part: John Coplans, Rona Pondick and
John Wesley,* fiction/nonfiction, New York

Effected Desire, Carnegie Museum of Art,
Pittsburgh (catalog)

Bedroom Eyes: Room with a View, Fullerton Art
Gallery, California State University, Pinkerton
(catalog)

SELECTED BIBLIOGRAPHY

1986 Brenson, Michael. "Emerging Sculptors:
1986," *New York Times,* December 26,
1986, p. C30.

1988 _____. "Rona Pondick: Beds,"
New York Times, September 9, 1988, p. C20.

Connor, Maureen. "Rona Pondick,"
Arts Magazine, May, 1988, p. 84.

Gookin, Kirby. *Artforum,* December 1988,
p. 120.

Myers, Terry R. *Arts Magazine,*
December 1988, p. 89.

1989 Spector, Buzz. "A Profusion of Substance,"
Artforum, October 1989, pp. 120-128.

1990 Hayt-Atkins, Elizabeth. "The Anxiety of
Influence," *Contemporanea,* September 1990,
pp. 66–73.

Myers, Terry R. "Pressing Pleasures:
The Urgent Sculptures of Rona Pondick,"
Arts Magazine, November 1990, pp. 90–95.

Pagel, David. *Artscribe International,*
September/October 1990, pp. 91–92.

Princenthal, Nancy. *Art in America,* January
1990, pp. 157–159.

1991 Brenson, Michael. *New York Times,* May 3,
1991, p. C19.

D'Amato, Brian. *Flashart,*
November/December 1991, p. 134.

Faust, Gretchen. *Arts Magazine,* September
1991, p. 79.

Hess, Elizabeth. "Nasty Girl,"
Village Voice, May 7, 1991, p. 85.

Neff, Eileen. *Artforum,* September 1991,
p. 133.

Pagel, David. "Guilt, Innocence Entangle in
Pondick's 'Heads,'" *Los Angeles Times,*
November 21, 1991, p. F3.

Saltz, Jerry. "The Living Dead Life of the
Body: The Sculpture of Rona Pondick,"
Balcon, no. 7, 1991, pp. 79–92.

1992 Hess, Elizabeth. "Dirty Laundry,"
Village Voice, May 12, 1992, p. 91.

Hills, Patricia. "The Naked Body, Censorship,
and the NEA," *ART New England,* August/
September 1992, pp. 14–16.

Schwabsky, Barry. "Shamelessness,"
Sculpture Magazine, July/August 1992,
pp. 44–51.

Kiki Smith

BORN 1954, NUREMBERG, GERMANY
LIVES AND WORKS IN NEW YORK

ONE-PERSON EXHIBITIONS

1982 *Life Wants to Live*, The Kitchen, New York

1987 *Kiki Smith: Drawings*, Piezo Electric Gallery, New York

1988 Fawbush Gallery, New York

1989 Galérie René Blouin, Montreal

Center for the Arts, Wesleyan University, Middletown, Connecticut

Concentrations 20: Kiki Smith, Dallas Museum of Art

1990 Centre d'Arte Contemporaine, Geneva

Fawbush Gallery, New York

The Periphery: Part 4, The Clocktower, Institute for Art and Human Resources, New York

Projects 24: Kiki Smith, Museum of Modern Art, New York

Tyler Gallery, Tyler School of Art, Temple University, Philadelphia

1991 Institute of Contemporary Art, Amsterdam (catalog)

University Art Museum, University of California, Berkeley (catalog)

1992 Williams College Museum of Art, Williamstown, Massachusetts, and Wexner Center for the Visual Arts, Columbus, Ohio (catalog)

Rose Art Museum, Brandeis University, Waltham, Massachusetts (catalog)

Kunstverein, Bonn

Fawbush Gallery, New York

Moderna Museet, Stockholm

Museum of Applied Arts, Vienna

SELECTED GROUP EXHIBITIONS

1982 *Natural History*, Grace Borgenicht Gallery, New York

Fashion Moda Store, Documenta VII, Kassel, Germany

1983 Hallwalls Contemporary Arts Center, Buffalo (catalog)

Science and Prophesy, White Columns, New York

Island of Negative Utopia, The Kitchen, New York

1984 *Inside/Out*, Piezo Electric Gallery, New York

Modern Masks, Whitney Museum of American Art, New York

1985 Moderna Museet, Stockholm

Synaesthetics: Writers and Artists, P.S. 1, Institute for Art and Urban Resources, New York

1986 *Donald Lipski, Matt Mullican and Kiki Smith*, The Clocktower, The Institute for Art and Urban Resources, New York

Public and Private: American Prints Today, The 25th National Print Exhibition, The Brooklyn Museum (catalog)

1987 *Emotope*, Büro-Berlin, Berlin

1988 *Committed to Print: Social and Political Themes in Recent American Printed Art*, The Museum of Modern Art, New York (catalog)

A Choice, Kunstrai, Amsterdam

Recent Acquisitions: 1986–1988, The Museum of Modern Art, New York

1989 *Cara Perlman and Kiki Smith*, Fawbush Gallery, New York

Projects and Portfolios: The 25th National Print Exhibition, The Brooklyn Museum (catalog)

New York Experimental Glass, The Society for Art in Craft, Pittsburgh (catalog)

1990 *Figuring the Body*, Museum of Fine Arts, Boston

Fragments, Parts and Wholes: The Body and Culture, White Columns, New York

The Unique Print: 70s into 90s, Museum of Fine Arts, Boston (catalog)

AIDS Timeline, A Project by Group Material, Wadsworth Atheneum, Hartford, Connecticut

Witnesses Against Our Vanishing, Artists Space, New York (catalog)

1991 *The Body*, Renaissance Society, University of Chicago (catalog)

The Body Electric: Zizi Raymond and Kiki Smith,
The Corcoran Gallery of Art, Washington,
D.C. (catalog)

Body Language, Lannan Foundation,
Los Angeles

The Interrupted Life, The New Museum of
Contemporary Art, New York (catalog)

1991 Biennial Exhibition, Whitney Museum of
American Art, New York (catalog)

1992　*Byron Kim/Kiki Smith,* A/C Project Room,
New York

Currents 20: Recent Narrative Sculpture,
Milwaukee Art Museum

Recent Acquisitions, The Museum of Modern
Art, New York

Signs of Life, University Galleries, Illinois State
University, Normal, Illinois

SELECTED BIBLIOGRAPHY

1984　Princenthal, Nancy. "Life Wants to Live,
The Kitchen," *ARTnews,* April 1984, p. 25.

Robinson, Walter, and Carlo McCormick.
"Report From the East Village: Slouching
Toward Avenue D," *Art in America,*
Summer 1984, p. 149.

1986　Brenson, Michael. "Donald Lipski, Matt
Mullican and Kiki Smith at The Clocktower,"
New York Times, January 10, 1986,
section 3 p. 22.

1988　Adams, Brooks. "Kiki Smith at Fawbush
Gallery," *Art in America,* September 1988,
pp. 182–183.

Faust, Wolfgang Max. "Emotope: A Project
for Büro-Berlin," *Artforum,* January 1988,
p. 131.

Mahoney, Robert. "Kiki Smith at Fawbush
Gallery," *Arts Magazine,* September 1988,
p. 106.

McCormick, Carlo. "Kiki Smith at Fawbush
Gallery," *Artforum,* October 1988, p. 145.

Smith, Roberta. "Kiki Smith at Fawbush
Gallery," *New York Times,* June 24, 1988,
section 3 p. 24.

1989　Decter, Joshua. "Kiki Smith at Wesleyan
University," *Flash Art,* October 1989, p. 134.

1990　Ahearn, Charlie. "Kiki Smith's Gut Reaction,"
Interview, November 1990, p. 26.

Humphrey, David. "Stained Sheets/Holy
Shroud," *Arts Magazine,* November 1990,
pp. 58–62.

Lyons, Christopher. "Kiki Smith: Body and
Soul," *Artforum,* February 1990, pp. 102–106.

Smith, Roberta. "Kiki Smith at The Museum
of Modern Art," *New York Times,*
November 23, 1990, p. C24.

Tallman, Susan. "The Skin of the Stone: Kiki
Smith at ULAE," *Arts Magazine,*
November 1990, pp. 31–32.

1991　Cyphers, Peggy. "Kiki Smith at The Museum
of Modern Art," *Arts Magazine,* February 1991,
p. 96.

Gardner, Colin. "Kiki Smith," *Artforum,*
October 1991, pp. 135–136.

Hess, Elizabeth. "Whitney Biennial: Upstairs,
Downstairs," *Village Voice,* April 30, 1991,
pp. 93–94.

Hixon, Kathryn. "And the Object is the
Body," *New Art Examiner,* October 1991,
pp. 20–24.

Kalina, Richard. "Read Dead," *Arts Magazine,*
December 1991, pp. 48–53.

Kimmelman, Michael. "Whitney Biennial,"
New York Times, April 19, 1991, C1.

Knight, Christopher. "Body Language:
Kiki Smith," *Los Angeles Times,* July 7, 1991,
pp. 74–76.

Schjeldahl, Peter. "Whitney Biennial:
Cutting Hedge," *Village Voice,* April 30, 1991,
pp. 93–94.

Schleifer, Kristen Brooke. "Inside and Out:
An Interview With Kiki Smith,"
Print Collector's Newsletter, July–August 1991,
pp. 84–87.

1992　Hess, Elizabeth. "Blood Sisters," *Village Voice,*
April 30, 1992, p. 55.

Tallman, Susan. "Kiki Smith: Anatomy
Lesson," *Art in America,* April 1992,
pp. 146–153.

David Wojnarowicz

BORN 1954, NEW JERSEY
DIED 1992, NEW YORK

SELECTED ONE-PERSON EXHIBITIONS

1982 Milliken Gallery, New York

1983 Hal Bromm Gallery, New York

Civilian Warfare Gallery, New York

1984 C.A.U.C., Center for Art and Communication, Buenos Aires

Civilian Warfare Gallery, New York

Anna Friebe Galerie, Cologne

Gracie Mansion Gallery, New York

1985 *Messages to the Public*, Times Square Spectacolor Board, New York

1986 Gracie Mansion Gallery, New York

Anna Friebe Galerie, Cologne

Cartier Foundation, Paris

1987 Gracie Mansion Gallery, New York

1989 P.P.O.W., New York

1990 *David Wojnarowicz: Tongues of Flame*, University Gallery, Illinois State University, Normal. Traveled to Santa Monica Museum of Art and Exit Art, New York (catalog)

Dorothy Goldeen Gallery, Los Angeles

In the Garden, P.P.O.W., New York. Traveled to Intermedia Arts, Minneapolis

SELECTED GROUP EXHIBITIONS

1980 *Lower Manhattan Drawing Show*, The Mudd Club, New York

Hunger; action installation with Julie Hair, Leo Castelli Gallery stairwell, New York

1982 *Famous Show*, Gracie Mansion Gallery

COLAB Show, Barbara Gladstone Gallery

1983 *Urban Pulses*, on-site installation, Pittsburgh Center for the Arts

Speed Trials, White Columns, New York

1984 *The East Village Scene*, Institute of Contemporary Art, Philadelphia

New Narrative Paintings from the Metropolitan Museum of Art, Museo Tamayo, Mexico City

New Galleries of the Lower East Side, Artists' Space, New York

1985 *1985 Biennial Exhibition*, Whitney Museum of American Art, New York

57th Street Between A and D, Holly Solomon Gallery, New York

1986 *Walls: Glier, Rodriguez, Wojnarowicz*, Norton Gallery of Art, West Palm Beach, Florida

1987 *Art Against AIDS*, Gracie Mansion Gallery, New York

1988 *Unknown Secrets: Art and the Rosenberg Era*, traveling exhibition organized by the Rosenberg Era Art Project (catalog)

1989 *Witnesses: Against Our Vanishing*, Artists Space, New York (catalog)

The Assembled Photograph, University Art Galleries, Wright State University, Dayton, Ohio

Art About AIDS, Freedman Gallery, Albright College, Reading, Pennsylvania

AIDS Timeline, organized by Group Material, University Art Museum, University of California, Berkeley

1990 *The Indomitable Spirit*, organized by Photographers and Friends United Against AIDS. Traveled to The International Center for Photography, Midtown, New York, and Los Angeles County Municipal Art Gallery (catalog)

The Decade Show: Frameworks of Identity in the 1980s, The New Museum of Contemporary Art, New York (catalog)

Word as Image, Milwaukee Art Museum (catalog)

AIDS/SIDA, Real Art Ways, Hartford, Connecticut

1991 *From Desire...A Queer Diary*, Richard F. Brush Art Gallery, St. Lawrence University, Canton, New York

1991 Biennial Exhibition, Whitney Museum of American Art, New York (catalog)

The Interrupted Life, The New Museum of Contemporary Art, New York (catalog)

From Media to Metaphor: Art About AIDS, organized by Independent Curators Incorporated. Traveled to Emerson Gallery, Hamilton College, Clinton, New York; Center on Contemporary Art, Seattle; and Sharidan Art Gallery, Kutztown, Pennsylvania (catalog)

1992 *Empowering the Viewer: Art, Politics and Community,* The William Benton Museum of Art, Connecticut State Art Museum, Storrs. Traveled to Tyler School of Art, Temple University, Elkins Park, Pennsylvania (catalog)

More Than One Photography, Museum of Modern Art, New York

SELECTED BIBLIOGRAPHY

1983 Moufarrege, Nicolas A. "The Famous Show," *Flash Art,* January 1983.

1984 Cotter, Holland. "David Wojnarowicz," *Arts Magazine,* September 1984, p. 45.

Robinson, Walter, and Carlo McCormick. "Slouching Toward Avenue D," *Art in America,* Summer 1984, p. 134.

1985 Cameron, Dan. "A Whitney Wonderland," *Arts Magazine,* Summer 1985, pp. 66–69.

1986 Harrison, Helen. "Urban Anxieties Reflected in Paintings from the East Village," *New York Times,* August 17, 1986, p. 22.

1987 Brenson, Michael. "David Wojnarowicz," *New York Times,* October 2, 1987, p. C27.

Loughery, John. "David Wojnarowicz," *Arts Magazine,* December 1987, pp. 104–105.

Smith, Paul. "David Wojnarowicz at Ground Zero," *Art in America,* September 1987, pp. 182–183.

1988 Rose, Matthew. "David Wojnarowicz: An Interview," *Arts Magazine,* May 1988, pp. 60–65.

1989 Chua, Lawrence. "David Wojnarowicz," *Flash Art,* Summer 1989, p. 148.

Deitcher, David. "Ideas and Emotions," *Artforum,* May 1989, pp. 122–127.

1990 Carr, C. "Portrait of the Artist in the Age of AIDS," *Village Voice,* February 13, 1990, pp. 31–36.

Hess, Elizabeth. "Queer in Normal," *Village Voice,* February 13, 1990, pp. 31–36.

_____. "Burning Down the House," *Village Voice,* November 20, 1990, p. 107.

Kimmelman, Michael. "An Artist Who Seeks Every Opportunity to Unnerve," *New York Times,* December 9, 1990, section 2 p. 35.

Lippard, Lucy R. "Out of the Safety Zone," *Art in America,* December 1990, pp. 130–139.

Parachini, Allan. "Fighting Back—Art and Survival: The Trials of David Wojnarowicz," *Los Angeles Times,* July 28, 1990, p. 1 pt. F.

1991 Adams, Brooks. "Grotesque Photography," *Print Collector's Newsletter,* January/February 1991, pp. 206–211.

Levin, Kim. "Intolerance or the Power of Images," *New Art,* February 1991, pp. 52–55.

Tallman, Susan. "Love and Death," *Arts Magazine,* December 1991, pp. 13–14.

1992 Carr, C. "David Wojnarowicz, 1954–1992," *Village Voice,* August 4, 1992, p. 3.

Goodeve, Thyrza Nichols. "No Wound Ever Speaks for Itself," *Artforum,* January 1992, pp. 70–74.

Kimmelman, Michael. "David Wojnarowicz, 37, Artist in Many Media," *New York Times,* July 24, 1992, p. D17.

SELECTED WRITINGS
BY DAVID WOJNAROWICZ

Close to the Knives: A Memoir of Disintegration, Vintage Books, New York, 1991.

Memories That Smell Like Gasoline, Artspace Books, San Francisco, 1992.

David Wojnarowicz has also produced numerous films, videos, recordings, and plays.

MIT List Visual Arts Center Staff

Nancy Adams, *Gallery Attendant*

Jill Aszling, *Registrar*

Cynthia Col, *Secretary*

Jennifer Johnson, *Gallery Attendant*

Kristin Johnson, *Gallery Attendant*

Kate Keeler, *Gallery Attendant*

Maura Keeler, *Gallery Attendant*

Katy Kline, *Director*

Toby Levi, *Administrative Officer*

Sean Mooney, *Gallery Assistant*

Ron Platt, *Curatorial Assistant*

Helaine Posner, *Curator*

Jon Roll, *Gallery Manager*

Katha Seidman, *Gallery Assistant*